THE NATIONAL GALLERY SCHOOLS OF PAINTING

Dutch Paintings

THE NATIONAL GALLERY SCHOOLS OF PAINTING

Dutch Paintings

CHRISTOPHER BROWN

Deputy Keeper, The National Gallery

The National Gallery, London,
in association with William Collins 1983

William Collins Sons & Co Ltd
London · Glasgow · Sydney · Auckland
Toronto · Johannesburg

British Library Cataloguing in Publication Data

Brown, Christopher, 1948–
 Dutch paintings.
 1. Painting, Dutch—Exhibitions
 2. Paintings, Modern—17th century—Netherlands—
 Exhibitions
 I. Title
 759.492′074 ND647

 ISBN 0–00–217145–7 Hbk
 ISBN 0–00–217146–5 Pbk

First published 1983
© The Trustees of the National Gallery

Photoset in Imprint
by Ace Filmsetting Ltd, Frome, Somerset.
Colour reproduction by
P.J. Graphics Ltd, London W3 8DH
Made and printed by
Staples Printers, Kettering, Ltd

Front cover shows a detail from *A Scene on the Ice near a Town* by Avercamp.

Back cover shows *A Woman Bathing in a Stream* by Rembrandt.

THE NATIONAL GALLERY SCHOOLS OF PAINTING

This series, published by William Collins in association with the National Gallery, offers the general reader an illustrated guide to all the schools of painting represented at the Gallery. Each volume contains fifty colour plates with a commentary by a member of the Gallery staff and a short introduction. The first three volumes in the series are:

Dutch Paintings by Christopher Brown
French Paintings after 1800 by Michael Wilson
Spanish and Later Italian Paintings by Michael Helston

Further volumes completing the series are due to be published in 1984 and 1985.

Dutch Paintings

The National Gallery's Dutch collection is one of the most famous and comprehensive in the world. This is largely a consequence of the enormous enthusiasm for Dutch pictures in Britain in the eighteenth and nineteenth centuries. Its foundations were laid with the acquisition, by bequest or purchase, of three great private collections, the most outstanding being that of the Prime Minister, Sir Robert Peel.

Compared to their contemporaries in France or Italy, the painters of seventeenth-century Holland are remarkable for the variety, of both style and subject-matter, of their work. This variety is reflected in the National Gallery's collection. It includes not only twenty Rembrandts, among them some of his finest portraits and religious scenes, and two Vermeers, but portraits, landscapes, genre paintings, townscapes, still-lifes and church interiors by other artists, many of the very highest quality. The

fifty Dutch paintings included in this selection have been chosen to illustrate this extraordinary range; they include such famous works as Hobbema's *Avenue at Middelharnis* and Rembrandt's *Self-Portrait Aged 63*, as well as lesser known paintings by such artists as Gerrit Berckheyde, Frans van Mieris and Esaias van de Velde.

CHRISTOPHER BROWN is Deputy Keeper at the National Gallery with responsibility for Dutch and Flemish seventeenth-century paintings. He has organized and catalogued a number of exhibitions, including *Art in Seventeenth-century Holland* (1976) and *Dutch Genre Painting* (1978/9), and has written widely on Northern painting of the sixteenth and seventeenth centuries. He is the author of several books, including *Carel Fabritius* (1980) and *Van Dyck* (1981).

Introduction

Compared to their contemporaries in France and Italy, the seventeenth-century painters of the United Provinces (usually referred to by the name of Holland, the leading province) are remarkable for the diversity of their work, both in style and subject matter, and this diversity is reflected in the National Gallery's large collection of Dutch paintings. About 450 Dutch paintings are on display at Trafalgar Square, slightly less than a quarter of the whole collection. The Dutch artists who are best known today are well represented: there are twenty Rembrandts, among them some of his finest portraits and religious scenes, and two interiors by Vermeer; but, in addition, there are hundreds of portraits, genre paintings, townscapes, still-lifes and church interiors, many of the very highest quality. The fifty paintings in this selection have been chosen to illustrate this extraordinary range: they include such famous works as Hobbema's *Avenue at Middelharnis*, De Hooch's *Courtyard in Delft* and two Rembrandt self-portraits, as well as lesser-known paintings by such artists as Gerrit Berckheyde, Frans van Mieris and Esaias van de Velde.

The comprehensiveness of the National Gallery's Dutch collection is a direct consequence of the enormous enthusiasm for Dutch paintings among British collectors in the eighteenth and nineteenth centuries. So intense was their appetite for Dutch pictures that when in recent years the Rijksmuseum in Amsterdam, the national collection of Dutch paintings, wished to acquire its first major landscapes by Aelbert Cuyp and Philips Koninck, the pictures were found in Britain, where they had been since the eighteenth century. It is surprising, therefore, to read a criticism of the representation of the Dutch school in the National Gallery in 1842, when it had been open for eighteen years. 'We are as yet most poor in the fine masters of the Dutch school,' wrote Anna Jameson in her *Handbook to the Public Galleries of Art in and near London*. 'There is not a single specimen of Hobbema or Ruysdael.

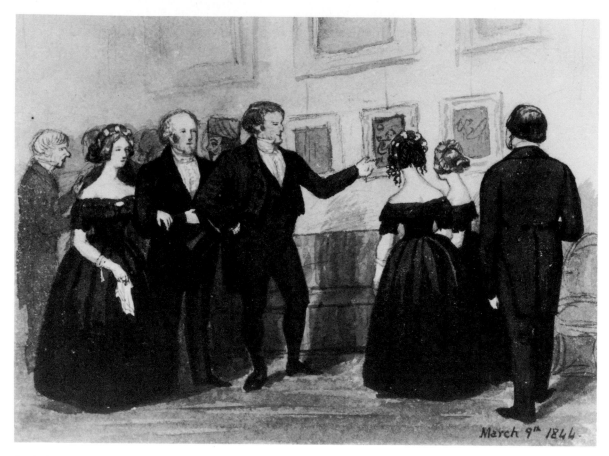

Sir Robert Peel Showing his Pictures by Jemima Wedderburn, 1844. From the Clerk Album, *NPG 2772. Reproduced by kind permission of the National Portrait Gallery, London.*

The specimens of Van de Velde are insignificant; and of the beautiful conversation-pieces of ter Borch, Gerard Dou, Netscher, Metsu, Ostade, Frans Mieris and their compeers, not one.'

All these artists are now represented at Trafalgar Square (and all but Caspar Netscher are represented in this book). Mrs Jameson's wishes were so spectacularly fulfilled largely as a consequence of the acquisition by the Gallery of three great collections of Dutch paintings, those formed by Sir Robert Peel, Wynn Ellis and George Salting, the first by purchase, the other two by bequest.

Dutch painting has always found admirers and collectors in Britain: Charles I, apparently through the offices of Constantijn Huygens (plate no. 24), had paintings by Rembrandt in his collection very early in the artist's career. The accession of William of Orange to the throne in 1688 naturally gave a strong impetus not just to the collecting of Dutch paintings but to a more pervasive Dutch style which was also felt in architecture, garden design and the decorative arts. It is true that the Grand Tourists of the eighteenth century rarely visited the Netherlands, and highbrow taste echoed Horace Walpole's outburst against the 'drudging mimics of nature's most uncomely coarseness', as he characterized Dutch

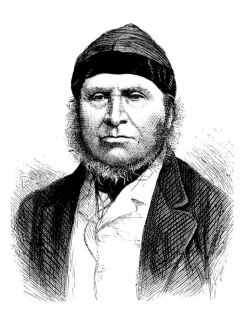

Portrait of Wynn Ellis from the Illustrated London News, *January 8th, 1876.*

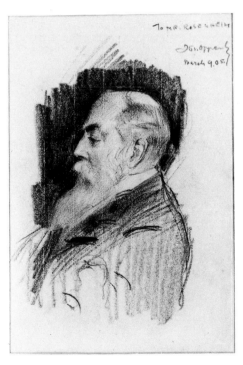

Portrait of George Salting by Joseph Oppenheim, 1905. NPG 1790. Reproduced by kind permission of the National Portrait Gallery, London.

landscape painters, but major collections of Dutch paintings were made, and the second half of the century saw what amounted to a rage for the works of Cuyp. It was in the early years of the nineteenth century, as a consequence of the break-up of great Continental collections caused by the Napoleonic wars, that the mass importation of Dutch paintings into Britain began and collectors like the Prince Regent, the third Marquess of Hertford and Sir Robert Peel competed for those pictures which were then considered the greatest achievements of the Dutch seventeenth century in portraiture, landscape and genre painting. It was their simplicity of subject matter, truth to nature, and meticulous technique (inspiring a particular enthusiasm for Dou and Van Mieris) which attracted these collectors.

Peel's attitude to his collection, which was made up of Dutch, Flemish and a few English paintings, is described by Mrs Jameson when in the introduction to *Private Galleries of Art in London* (1844) she relates a conversation with the Prime Minister: ' "I cannot express to you" said a most distinguished statesman of the present day, as we stood together in the midst of his beautiful pictures – "I cannot express to you the feeling of tranquillity, of restoration, with which, in an interval of harassing official business, I look round me here". And while he spoke, in the slow, quiet tone of a weary man, he turned his eyes on a forest scene of Ruisdael and gazed on it for a minute or two in silence – a silence I was careful not to break – as if its cool, dewy verdure, its deep seclusion, its transparent waters stealing through the glade, had sent refreshment into his very soul.' The painting which on this occasion refreshed the Prime Ministerial soul was probably *A Pool surrounded by Trees* (no. 38).

Peel came from a wealthy manufacturing family and, when he succeeded as second baronet in 1830, inherited a great fortune. He did not flinch from paying high prices for the paintings he wanted: he bought a Frans van Mieris (no. 28) and a Dou (no. 10) at the sale of William Beckford's collection in 1823, paying 305 and 1270 guineas respectively. Three years later he paid 920 guineas for a ter Borch (no. 4). It was in 1871, twenty-one years after his death, that Peel's collection was purchased for the nation for £75,000. It consisted of seventy-seven paintings – fifty-five Dutch, twelve Flemish and ten English. The acquisition of this group of Dutch paintings corrected the Italianate bias of the National Gallery and must have appeased the shade of Mrs Jameson who believed Peel's collection to be 'the most remarkable and valuable with which I am acquainted'. As well as the paintings already mentioned, the Dutch pictures included two outstanding De Hoochs of the Delft period (see no. 20), a Rembrandt portrait, three Cuyps (among them no. 9), three Hobbemas (including his masterpiece,

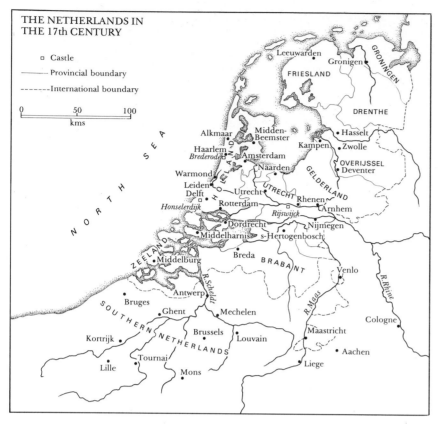

THE NETHERLANDS IN
THE 17th CENTURY

□ Castle

——— Provincial boundary

------- International boundary

0 50 100
kms

The Avenue at Middelharnis, no. 19), three Adriaen van de Veldes, seven Willem van de Veldes and five Wouwermans.

Only five years later, in 1876, the holding of Dutch paintings at the Gallery was further strengthened by the bequest of Wynn Ellis, a successful entrepreneur and Free Trade Liberal MP. His collection epitomizes the taste of a generation of early Victorian businessmen who had not been instilled with accepted conventions about the merits and demerits of the various schools of painting and who simply enjoyed the realistic emphasis of Dutch art. Among his Dutch paintings were three superb Ruisdaels (the most outstanding was no. 39), three Jan van de Cappelles, five Willem van de Velde marines, as well as paintings by Van der Heyden, Schalcken and Nicolaes Berchem.

George Salting was a far more eclectic collector, whose first love was Chinese porcelain. His large collection of paintings came to the National Gallery on his death in 1910 and in addition to outstanding early Netherlandish and Italian pictures there was a fine group of Dutch paintings including two Van de Cappelles, a Cuyp, three Van Goyens, two Hals portraits, a Maes, two Metsus, four Ruisdaels, a Saenredam, six Jan Steens (including the *Skittle Players*, no. 42) and the Vermeer *Woman seated at a Virginal* (no. 48).

These three large collections form the core of the Gallery's representation of Dutch paintings. In subsequent years it has been added to – by bequest, purchase and, more recently, by private treaty sale arrangements. Hendrick ter Brugghen, for example, a major Dutch figure painter, was not included until 1926; a landscape by Esaias van de Velde entered the collection only in 1957 (no. 45). Outstanding recent acquisitions included in this selection are paintings by Frans Hals (no. 15), Philips Koninck (no. 25), Jan Steen (no. 43) and, this year, a third ter Brugghen (no. 7). It is, therefore, a collection which is constantly growing and changing, and one which – perhaps more than any other in the world – enables the visitor to grasp not only the richness and diversity of Dutch painting in the seventeenth century but also its quality, which is throughout consistently high, as can be seen in the pages that follow.

PLATE 1

Hendrick Avercamp, 1585–1634

A Scene on the Ice near a Town (No. 1479)

Oak panel, 58 × 89.9 cms
Signed, in the right foreground, with the artist's monogram: HA
Purchased, 1896.

Hendrick Avercamp was trained in Amsterdam in the studio of one of the Flemish followers of Pieter Bruegel the Elder. These artists, Protestants who fled from Antwerp when the city was reconquered by the Spanish in 1585, brought with them a particular interest in the placing of figures in a naturalistic landscape which provided a powerful stimulus to the development of landscape painting in the north.

Avercamp, who was a deaf mute known as *de stom van Campen*, returned from Amsterdam to the small town of Kampen in north-west Holland and apparently remained there for the rest of his life. He evolved his own very characteristic interpretation of Bruegel's style, concentrating on the depiction of aspects of everyday life in Kampen. His paintings rarely include topographically accurate features and although this picture is said to show Kampen – with the town's principal brewery, the Half Moon, on the right – it is difficult to be certain. However, the painting certainly includes much carefully observed detail with figures on skates, in horse-drawn sleighs and playing *Kolf* (an early form of golf) on the frozen river.

In painting this scene, Avercamp would have made use of his sketchbooks filled with drawings and watercolours of figures taken from the life: the final scene, painted in his studio, would be an imaginative combination of such drawings. A particular aspect of his work and one that provides especial fascination for the modern viewer is the detailed description of the face and dress of each figure in the foreground and in the middle distance. Avercamp has presented an intentional contrast between the richly-dressed aristocratic couple in the lower left-hand corner – the man with slashed sleeves and plumed hat, and the woman with her elaborately starched lace ruffs, gold chain and brightly-coloured sash – and the soberly dressed townspeople in modest black-and-white beside them. The buildings and the sky are rendered in Avercamp's subtle, personal range of pinks, reds and whites.

Avercamp's work shows little stylistic development; when he had perfected his own manner of depicting the world with which he was familiar, he saw no need to change it. For this reason, his paintings which, though usually signed, are rarely dated, are difficult to place in a chronological sequence. This picture was probably painted around 1610.

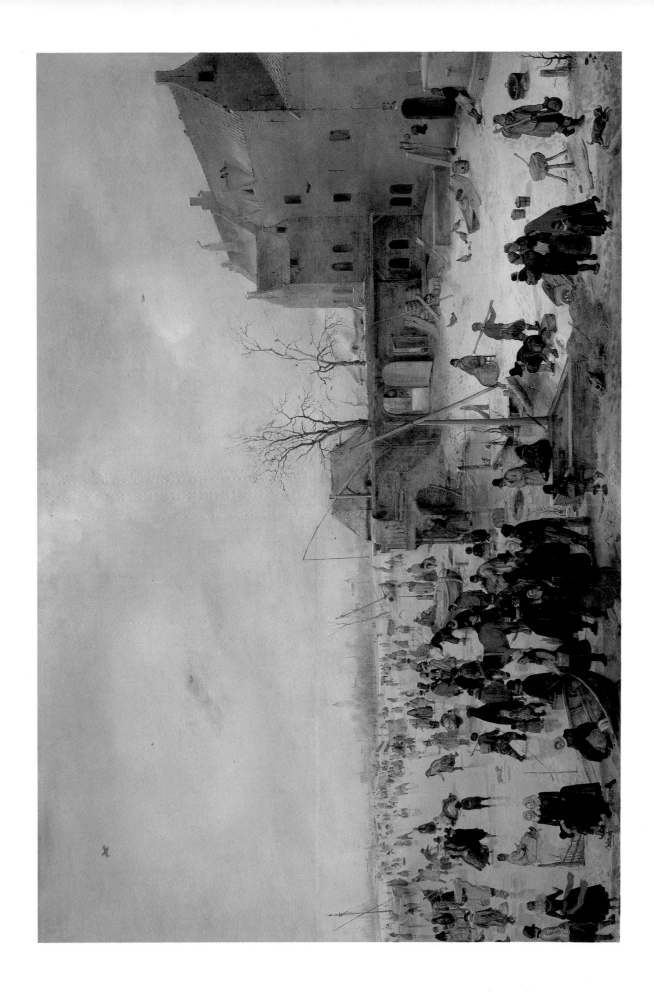

PLATE 2

Nicolaes Berchem, 1620–1683

Peasants with Four Oxen and a Goat at a Ford by a Ruined Aqueduct (No. 820)

Oak panel, 47.1 × 38.7 cms
Signed, bottom left: Berchem
Purchased with the Peel collection, 1871.

Nicolaes Berchem, the son of a distinguished painter of still-life, Pieter Claesz., was born in Haarlem. The town was the leading centre of landscape painting in Holland in the first half of the seventeenth century and among Berchem's teachers (listed by his earliest biographer) was the landscapist Jan van Goyen. Like many Dutch artists, Berchem went to Italy (with his cousin Jan Baptist Weenix) immediately after completing his training. He was in Rome late in 1642 and remained there for three years. While in Italy Berchem made many drawings of the landscape, particularly the Roman Campagna, its cattle and peasants. On his return he mined this rich material throughout a long and extremely productive career, painting (and etching) hundreds of Italianate pastoral scenes. As can be seen in this painting, he interpreted the Italian landscape and the life of its peasants in an idyllic manner, emphasizing its timeless continuity by the inclusion of romantically decayed antique monuments. These monuments, as here, are not identifiable, being only loosely based on actual surviving remains of antiquity. In keeping with his subject, Berchem uses a bright, highly-coloured palette and paints in broad, loose brushstrokes.

In Holland in the seventeenth century there was a voracious demand for exotic landscapes of this type and Berchem was a highly successful artist. In the last twenty years of his life he is recorded in Amsterdam, a far larger town than his native Haarlem with a more active art market, and had settled there by 1677. He was also a highly influential teacher: Pieter de Hooch and Carel Dujardin were among his pupils. Berchem's work was widely imitated and copied during his lifetime and his paintings were enthusiastically sought after in France in the eighteenth century and in England in the nineteenth. This painting, having been in a distinguished Amsterdam collection (that of Gerrit Braamcamp) in the mid-eighteenth century, was bought in Paris by the Duc de Chabot in 1780 and in London in 1840 by Sir Robert Peel.

Berchem was admired not only by collectors but also by painters in eighteenth-century France and François Boucher, in particular, was an admirer of his work.

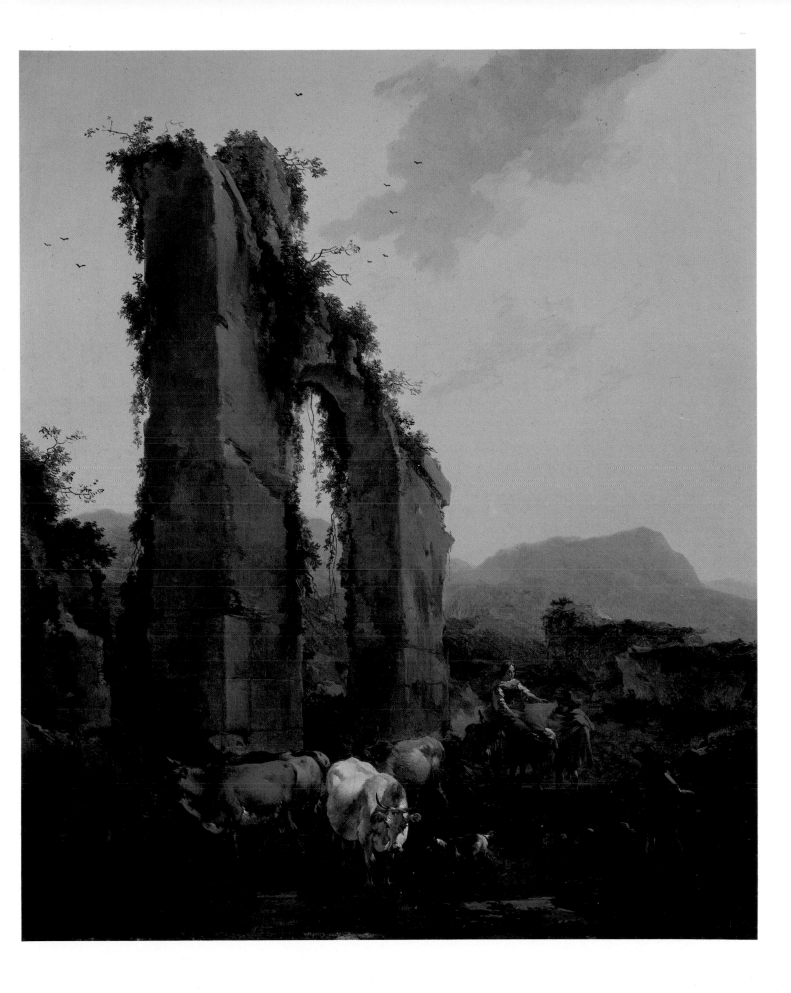

PLATE 3

Gerrit Berckheyde, 1638–1698

The Market Place and Great Church at Haarlem (No. 1420)

Canvas, 51.8 × 67 cms
Signed, on the base of the third column from the right, Gerrit Berck Heyde/1674
Purchased, 1894.

The Dutch painters' love of describing their world, together with an intense pride in the appearance of their towns, combined to produce a distinct type of Dutch seventeenth-century painting, the townscape. It was especially popular in the third quarter of the century and one of its finest exponents was Gerrit Berckheyde who lived and worked in Haarlem. In this painting he shows the principal square in his native town from the north-west: the spectator stands, as it were, in front of the town hall, in the shadow cast by its portico. He looks towards the Great Church (Grote Kerk) dedicated to Saint Bavo, begun in the late fourteenth century and completed a century later. (The spire is an addition of 1519/20.) Today the church is virtually unchanged but the stalls on its north side which are those of the town's fish market have long since disappeared. The last of the row of buildings on the right, just before the church, is the meat market (*Vleeshal*). With its stepped gable and delicate banding of red brick and white stone, this is one of the most important late Renaissance buildings in Holland: the architect was Lieven de Key and it was built in 1602/3. Its appearance is unchanged but many of the other buildings in the row have been altered or demolished during the intervening three centuries. The bell-tower of S. Bavo, seen here just beyond the fish market, and the portico of the town hall, have also been destroyed.

Gerrit Berckheyde painted the market place in Haarlem many times – the National Gallery also has a painting of the view from the Church towards the town hall – and he often repeated the same view. These paintings would have been purchased by proud citizens of Haarlem who wished to be reminded of the beauty of their town and of the distinction of both its medieval and modern buildings.

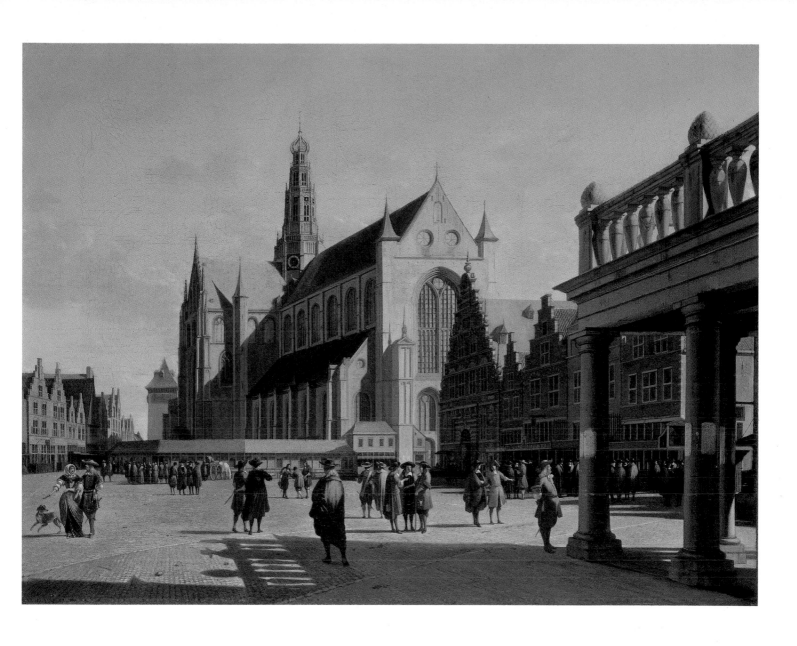

PLATE 4

Gerard ter Borch, 1617–1681

A Young Woman playing a Theorbo to Two Men (No. 864)

Canvas, 67.6 × 57.8 cms
Purchased with the Peel collection, 1871.

With Pieter de Hooch and Johannes Vermeer, Gerard ter Borch is one of the most outstanding of Dutch genre painters. Their genre paintings are firmly based on the artists' observation of life around him and yet elements from everyday life are often combined to suggest a particular mood, create an intriguing situation or even to point a subtle moral.

Ter Borch, the son of a painter, was born in Zwolle and trained there in the studio of his father and also in the Haarlem workshop of the landscape painter Pieter Molijn. In his youth he travelled widely in Europe – to Germany, Italy, England, France and Spain. By 1654 he had settled in Deventer, in his native province of Overijssel, where he achieved both professional and social success. He became one of the town's regent class and painted portraits of his peers.

In the genre scenes of his early years ter Borch showed the life of soldiers, taking his subject-matter from the successful Amsterdam painters Pieter Codde and Willem Duyster. After settling in Deventer, however, his genre scenes show elegant interiors, as in this painting, in which small groups of figures talk, drink and make music. Ter Borch sets up subtle and deliberately ambiguous relationships between the figures: in this painting, for example, are both the men suitors? Music is often associated with love in ter Borch's paintings and, indeed, in Dutch genre paintings as a whole. In addition to his skill in setting his scene, ter Borch possesses a remarkable technical gift, particularly in the description of texture. No Dutch artist rendered satin better than ter Borch nor was able to differentiate between the textures of a velvet cloak lining, a table carpet, a silver candlestick holder and a sword sash with such skill.

This picture was painted in about 1670. Thirteen years before, in 1658, ter Borch is recorded to have been in Delft when he witnessed a document with the young Vermeer. This recently discovered evidence of a direct contact between the two artists confirms what has long been suggested: that the simplicity and restraint of ter Borch's style exercised an important influence on the Delft painter.

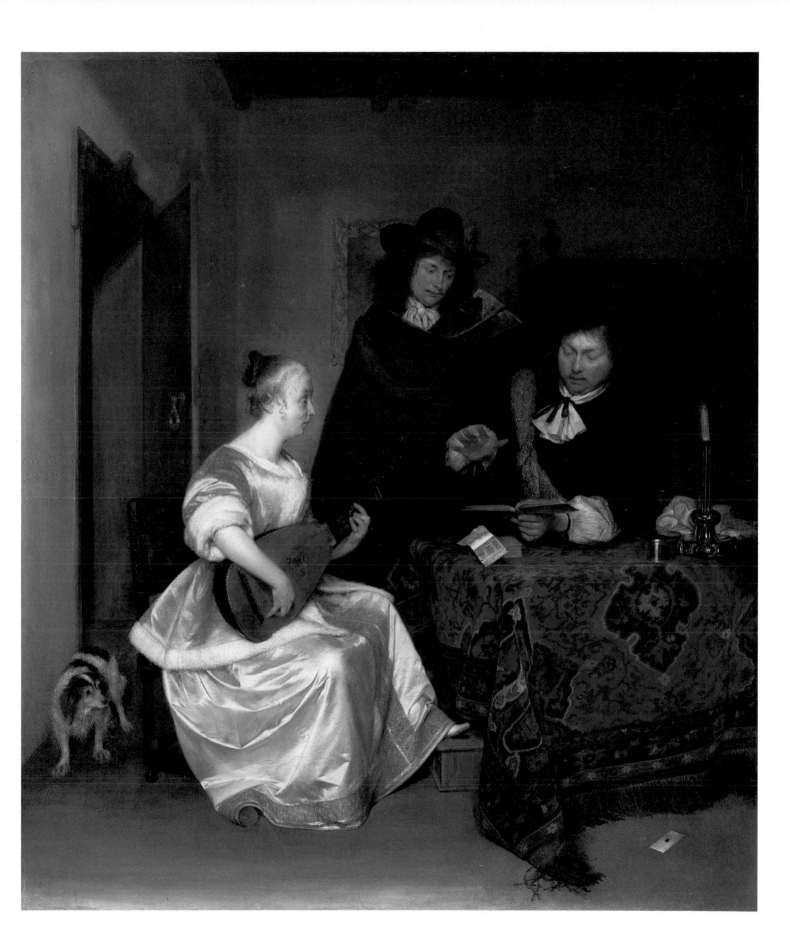

PLATE 5

Gerard ter Borch, 1617–1681

The Swearing of the Oath of Ratification of the Treaty of Münster, 15th May 1648 (No. 896)

Copper, 45.4 × 58.5 cms
Signed, on a tablet hanging on the wall at the left: G T Borch. f. Monasterij.
A. 1648 (GTB is in monogram)
Presented by Sir Richard Wallace, 1871.

Ter Borch was as skilled a painter of portraits as he was of genre scenes. This copper panel – copper was chosen for its flat surface on which detail can be more precisely rendered than on even the most finely-woven canvas – is his finest achievement as a portrait painter.

It records a scene of the very greatest significance in Dutch history: the formal end of the war between Spain and the United Provinces, which had been going on for eighty years. This treaty was a triumph for the Dutch: the Spanish renounced all claim to sovereignty over the United Provinces, which had been part of the Hapsburg empire, acknowledged their independence and even recognized their colonial possessions. The negotiations began in 1646 in Münster in Westphalia and culminated in the swearing of the oath of ratification in the town hall. The Spanish delegation, led by the Conde de Peñaranda – seen here reading the oath from the paper in his left hand, with his right hand resting on an open Bible – were the first to swear, followed by the Dutch led by Bartold van Gent, who stands on his right. Ter Borch, however, has shown both delegations swearing the oath at the same time; the soberly-dressed Dutch raise their right hands.

The treaty documents, in their elegant red caskets, stand on the table in front of them. The semi-circular arrangement of the figures is a pictorial convention rather than an accurate depiction of the event.

Ter Borch was in Münster when the swearing of the oath took place and he included his own self-portrait in this painting, in the front row, on the extreme left, gazing out at the spectator. While there he also painted individual portraits of a number of the delegates, including Peñaranda. It is unknown whether this picture was painted as a commission. An early biographer records that ter Borch asked the very high price of six thousand guilders (Rembrandt was paid only 1500 guilders for *The Night Watch*) but as he was offered less he kept it and, indeed, it does seem to have remained in the artist's family. Later it was owned by two distinguished French collectors, the Prince de Talleyrand and the Duc de Berry, an equally distinguished Russian collector Prince Anatole Demidoff and finally a great English collector, the 4th Marquess of Hertford. It was given to the National Gallery in 1871 by his son, Sir Richard Wallace, who presented the Wallace Collection to the nation.

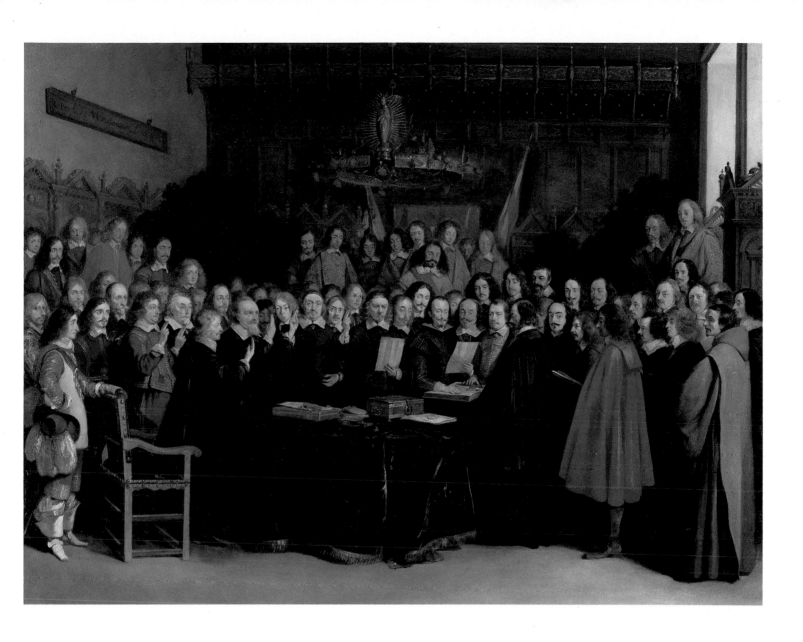

PLATE 6

Jan Both, c. 1618–1652

Peasants with Mules and Oxen on a Track near a River (No. 959)

Copper, 39.6 × 58.1 cms
Signed, on a stone at the left edge, J Both (JB in monogram)
Wynn Ellis Bequest, 1876.

Painters from Utrecht, the town in which Jan Both was born, traditionally travelled to Italy after the completion of their training. Both, a pupil of Abraham Bloemaert, crossed the Alps in about 1635, accompanied by his brother Andries. The two young artists shared a house in Rome but while Andries drew and painted picturesque figures and street scenes, Jan left the city and travelled in the countryside, sketching from nature. Jan was back in Utrecht in 1641 (Andries died in Venice in the same year) and he used the raw material of his Italian sketches for a series of idyllic landscapes. All are suffused by a rich, golden light which was to be adopted by a whole generation of Dutch landscape painters, including Aelbert Cuyp who worked in Dordrecht.

In this painting on copper, Both employs a high viewpoint, creating an extensive landscape vista of a sluggish river and its densely wooded banks with, further away, a plain and a range of low mountains. They are seen through the warm golden haze of a late summer afternoon in the Roman Campagna. In the foreground, where the branches and leaves of the trees, some tinged by the sun, are painted with the kind of painstaking detail possible on a copper panel, a peasant slowly rides homewards on his mule while another is distracted from his oxen by a bird glimpsed on a tree. There is a profound sense, not just of the strength of the sun and its soporific effect, but also of the continuity from ancient times of these rural occupations.

In the years after his return to Utrecht, Both painted Italianate landscapes, occasionally with religious or mythological figures in them. (The National Gallery also possesses a *Judgement of Paris* by Both; the figures were painted by a fellow Utrecht artist, Cornelis van Poelenburgh.)

PLATE 7

Hendrick ter Brugghen, c. 1588–1629

The Concert (No. 6483)

Canvas, 99.1 × 116.8 cms
Purchased, 1983.

Ter Brugghen's style is a very individual interpretation of that of Caravaggio, who was one of the handful of artists who effected a revolution in the course of European painting. Caravaggio's powerful influence was felt not just in Italy, but also in France, Spain and the Netherlands.

Ter Brugghen had been trained in his native town of Utrecht in the studio of Abraham Bloemaert. He travelled to Italy in about 1605 and lived in Rome for ten years: there he studied the work of Caravaggio in the Cerasi Chapel of Sta. Maria del Popolo and in S. Luigi dei Francesi, as well as the work of his immediate Roman followers like Bartolomeo Manfredi and Orazio Gentileschi. Although today we are first struck by Caravaggio's dramatic lighting – his highly original *chiaroscuro* – contemporaries remarked on his naturalism, a conscious rejection of the idealization of the High Renaissance. Both features found their place in ter Brugghen's art: in this painting, the light from the candle in the foreground and the lamp on the back wall play on the faces of the musicians and create deep shadows in the elaborate folds of their drapery. His naturalism can be seen in the strongly characterized heads and in the detailed treatment of the still-life. Not only are the *chiaroscuro* and the painting's naturalism owed to Caravaggio, but also this type of half-length composition showing a candlelit musical party with the figures in flamboyant, even theatrical, dress can be paralleled in his work. To this Caravaggesque subject ter Brugghen brings his own quite individual manner of representing form in a few simple planes and, even more striking, his remarkable palette which includes light blues, lemon, purple and cerise.

Ter Brugghen had returned from Italy to Utrecht by 1615; he was accepted into the local guild as a master in the following year and spent the rest of his life in the town. The exact chronology of his work is difficult to establish, but this painting, probably his finest secular work, should be dated around 1626.

The painting seems to have come to England at a very early date, around 1700, when it was purchased by Lord Somers, Lord Chancellor to King William III.

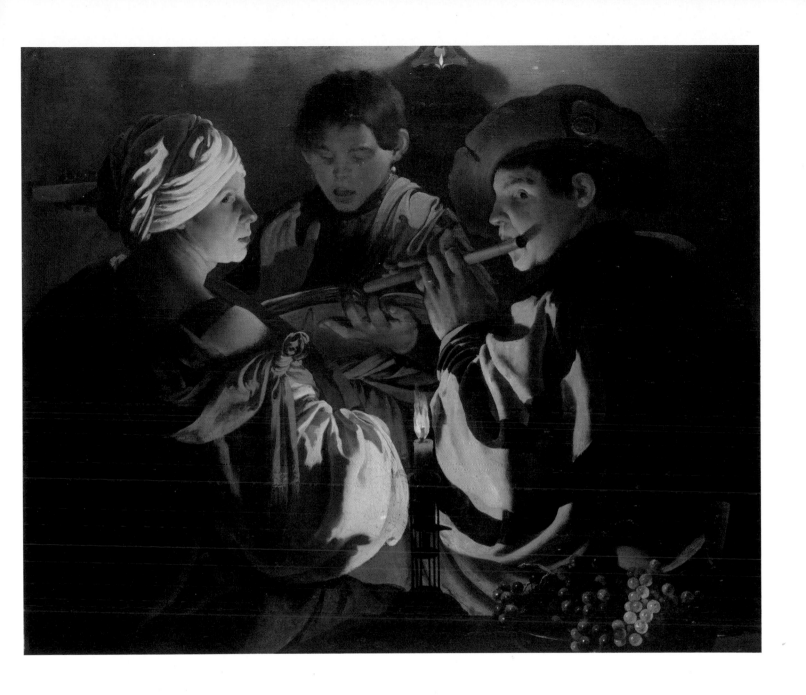

PLATE 8

Jan van de Cappelle, c. 1624–1679

A River Scene with a Large Ferry and Numerous Dutch Vessels at Anchor (No. 967)

Canvas, 122 × 154.5 cms
Signed, on the rudder of the ferry, J V Cappelle
Wynn Ellis Bequest, 1876.

Marine subjects are one of the most important categories of Dutch seventeenth-century painting. Their numbers reflect the importance of ships and the sea to the Dutch, whose economic prosperity rested to a large extent on the success of the merchant marine.

Jan van de Cappelle is today judged one of the greatest of Dutch marine painters. According to a contemporary he was self-taught but he clearly took as his models Simon de Vlieger and Jan Porcellis, works by both of whom were in his own extensive collection. Porcellis had been the first marine painter to break with the 'mannerist' style, best exemplified by the work of Hendrick Vroom, in which elaborately described two-dimensional ships were tossed on the top of bright green waves. Porcellis adopted a very restricted grey, black and white palette to paint realistic storms at sea, a style which De Vlieger developed in the direction of greater naturalism by extending the range of colours and of subject-matter. Van de Cappelle's marine paintings can be usefully compared to Ruisdael's landscapes. He employs, as Ruisdael often did, a low horizon, and consequently the sky assumes almost as great a significance as the scene beneath it. Though carefully composed, Van de Cappelle's paintings aim to give the impression of a scene glimpsed in reality, a *coup d'oeil*, by cutting off parts of ships on either side of the canvas. This apparent realism is also a feature of Ruisdael's skilfully constructed landscapes. 'Selective naturalness' was a phrase used by a contemporary about Porcellis's marine paintings and it can equally be applied to the work of Van de Cappelle and Ruisdael.

In this painting from the 1660s, the focus of the composition is the flat-bottomed ferry (*veerpont*) used to bring passengers and cargo freight (including in this case a cannon) ashore from the passenger ship (*wijdschip*) with its deeper draught. In the middle ground on the right is a States yacht, favoured by dignitaries, flying the Dutch colours. Progress in both is slow because the wind has died, as can be seen in the unruffled surface of the water which reflects the sails of the ships.

Jan van de Cappelle, who lived and worked in Amsterdam, produced relatively few paintings. He owned a dye-works from which he derived his considerable wealth and he presumably devoted a good deal of his time to commerce.

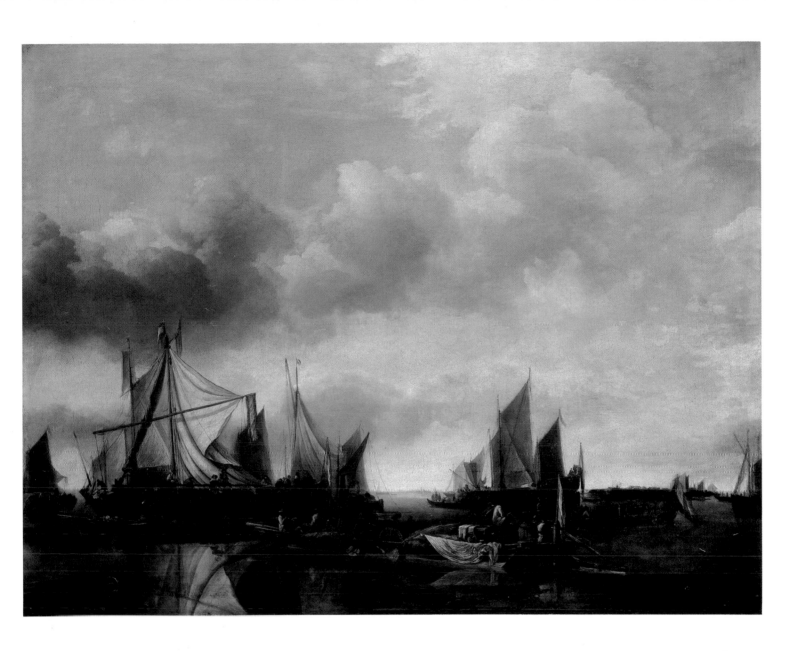

PLATE 9

Aelbert Cuyp, 1620–1691

A Herdsman with Five Cows by a River (No. 823)

Oak, 45.4 × 74 cms
Signed, bottom right, A:cuyp:
Purchased with the Peel collection, 1871.

Aelbert Cuyp lived and worked in Dordrecht, which although a small provincial town had a flourishing school of painting. Nicolaes Maes, Samuel van Hoogstraten and Aert de Gelder also worked in the town.

Aelbert's father, Jacob, was a portrait painter who trained his son and the two collaborated – figures by Jacob, landscape and cattle by Aelbert – on a number of paintings. Aelbert's early landscape style is close in both its grey-green palette and free technique to that of Jan van Goyen but in the early 1640s he discovered the style which Jan Both had brought back from his stay in Italy. Cuyp never visited Italy but he adopted an idiosyncratic version of Both's style. He bathed his very Dutch landscapes in a golden Italian sunshine which sparkles on the water and catches the flanks of his cattle.

Having adopted and refined this peculiar version of the Italianate landscape style, Cuyp practised it for many years of a successful career, which he ended as a member of the regent class of Dordrecht and an elder of the Reformed Church, the owner of a fine town house and an extensive country estate. Because his style did not change significantly his paintings are difficult to date with any precision, but this landscape may be from the mid-1650s.

Cuyp's work has been enthusiastically collected in Britain since 1760 when Lord Bute acquired the superb, large-scale *River Landscape* which is still owned by his descendants, with the consequence that his best paintings are in public and private collections in Britain. This painting was owned by John Smith, the early nineteenth-century London dealer, who compiled the first systematic listing of the work of the Dutch painters. It was subsequently in the collection of Sir Robert Peel. The defecating herdsman had been painted out by a previous owner and was only revealed by a recent cleaning.

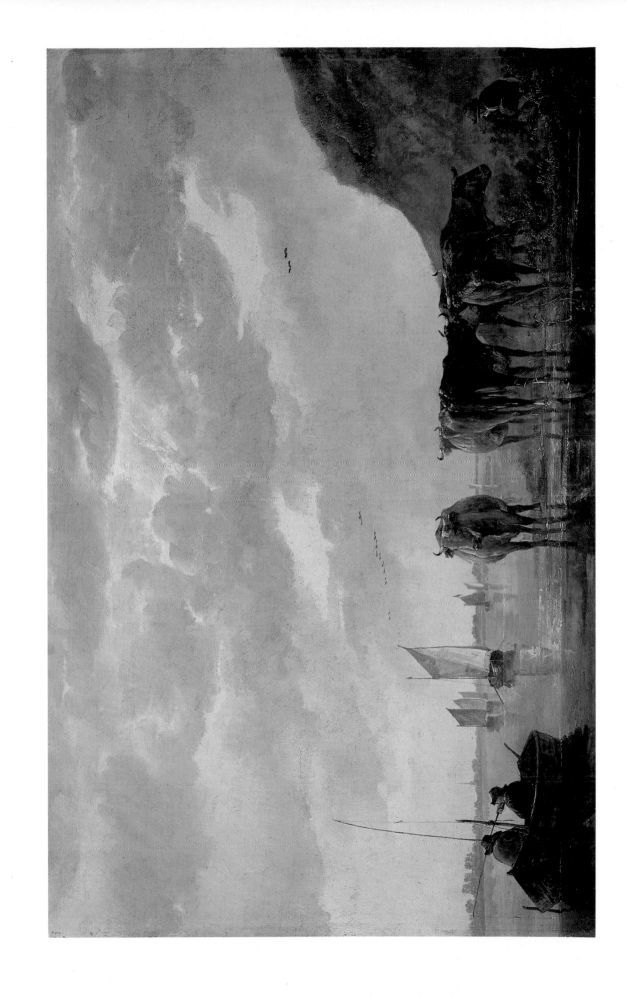

PLATE 10

Gerrit Dou, 1613–1675

A Poulterer's Shop (No. 825)

Oak, 58 × 46 cms
Signed, on the sill, G Dou (GD in monogram)
Purchased with the Peel collection, 1871.

Dou was Rembrandt's first pupil but came to paint in a manner quite different from that of his master. Like Rembrandt, Dou was a native of Leiden; his father was a glass engraver and after training and then working for a time in his father's workshop, Dou joined Rembrandt in 1628. He remained with him until Rembrandt moved to Amsterdam, probably late in 1631. Dou's meticulous, detailed technique owes much to his earliest training with his father, although Rembrandt's technique in his Leiden years was far more precise in the representation of detail than it was later to become. Dou remained in his native town and enjoyed a long and successful career. He was the founder of a local school known as the *fijnschilders* ('fine painters') which continued well into the eighteenth century. Dou was one of the few Dutch seventeenth-century painters to have a truly international reputation: he was invited to England by Charles II.

Dou's mature technique did not change and this painting could be dated at almost any time between 1650 and 1670, although it appears to have more affinities with the artist's latest works. A niche of this type was used by Dou to frame genre scenes, in this case the interior of a shop selling poultry and game. Beneath the ledge of the niche, on which a duck, a peahen and other birds are displayed, is a bas-relief after a design by François Duquesnoy, a Flemish sculptor who worked in Rome in the first half of the seventeenth century.

Dou's highly finished style, successfully adopted by his best pupil, Frans van Mieris, was not only successful during his lifetime. Dou's work was passionately collected in France in the eighteenth century and in England in the nineteenth. This painting was successively in the collections of the Duc de Choiseul, the Prince de Conti and the Duc de Chabot, passing from one to the other for very high prices. It was purchased in Paris in 1814 by William Beckford, the distinguished collector, author and creator of Fonthill Abbey. It was bought at the Fonthill Abbey sale in 1823 by the dealer John Smith for Sir Robert Peel at the high price of 1270 guineas.

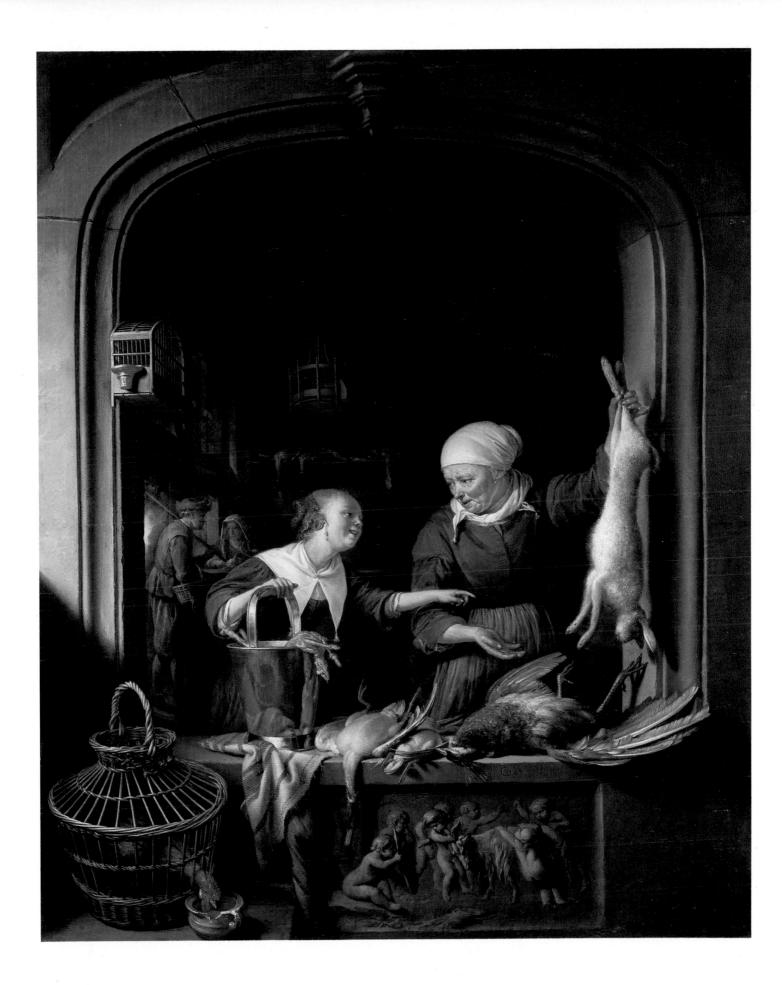

PLATE 11

Carel Fabritius, 1622–54

A View in Delft with a Musical Instrument Seller's Stall (No. 3714)

Canvas (stuck down on a walnut panel), 15.5 × 31.6 cms
Signed, on the wall at the left: C. FABRITIUS./1652
Presented by the National Art-Collections Fund, 1922.

The work of Carel Fabritius is extremely rare, but in it he emerges as a brilliant and experimental artist. Born at Midden-Beemster, a village thirty kilometres north of Amsterdam, he seems to have received his earliest training from his father, the local schoolmaster who was also an amateur painter. In 1641 he moved to Amsterdam and entered Rembrandt's studio, where he remained for a year and a half. He is undoubtedly the most outstanding of Rembrandt's many pupils. In 1650 he is first recorded in Delft where he was one of a group of painters – Pieter de Hooch, Jan Steen, Emanuel de Witte and Johannes Vermeer were among the others – who transformed the small provincial town into one of the leading artistic centres in the Netherlands in the third quarter of the century. In 1654 Fabritius died in the explosion of the municipal arsenal in Delft.

Samuel van Hoogstraten, who was in Rembrandt's studio at the same time as Fabritius, wrote that Carel was interested in perspective and illusionism: he described some *trompe l'oeil* decorations which Fabritius painted in a house in Delft. All that remains of this aspect of Fabritius' work is this small painting. It is a view in the centre of Delft, from the corner of the Oude Langendijk and the Oosteinde, looking north-west. In the centre is the New Church and, just to the left of it, in the distance, the Town Hall. On the right are the houses of the Vrouwenrecht. The New Church and the Town Hall exist in much the same state today, although a spire was added to the tower of the latter in the nineteenth century. The Oude Langendijk, the canal along the south side of the New Church, has been filled in. The second house from the right in the Vrouwenrecht survives but the others have been rebuilt. The precise way in which this small painting was displayed has been much discussed: it seems most likely that it was curved against the back of a triangular wooden peep show. It would be viewed through a peep-hole from the point at which the two longest sides of the triangle met. This arrangement would account for the painting's perspectival distortions.

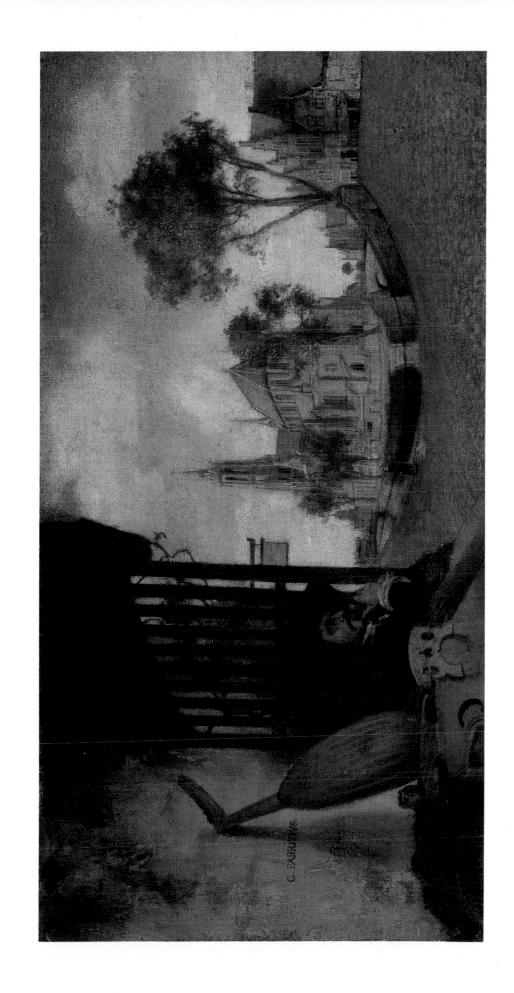

PLATE 12

Carel Fabritius, 1622–1654

Portrait of a Man in a Fur Cap and a Breastplate (Self-portrait) (No. 4042)

Canvas, 70.5 × 61.5 cms
Signed, bottom right, C. fabritius/.1654
Purchased, 1924.

There is no documented portrait of Carel Fabritius but this painting, dated in the year of his tragic death at the age of thirty-two, appears to show the same model as a picture in the Museum Boymans-van Beuningen in Rotterdam. The direct gaze of the eyes and the use of self-portrait compositions familiar from the work of Rembrandt and his pupils make it likely that both are self-portraits. Rembrandt painted a number of self-portraits wearing a breastplate in the 1630s and thereafter it became a popular self-portrait type among his pupils. Though aware of such prototypes, Fabritius chooses an unusual background, placing himself starkly against a cloudy sky. The Rotterdam por-trait, in which the painter shows himself, dressed in his working smock, against crumbling plaster-work, is painted with strong contrasts of light and dark, and a thick application of paint. By the time he came to paint 1654 *Self-Portrait*, however, Fabritius had abandoned dramatic contrasts and adopted a new technique in the application of paint. It is lightly, even delicately, laid on to the canvas and the modelling of the features of the face is done with extreme subtlety and care. These changes in style and technique were perhaps a consequence of Fabritius' contact with the other painters active in Delft in the early 1650s.

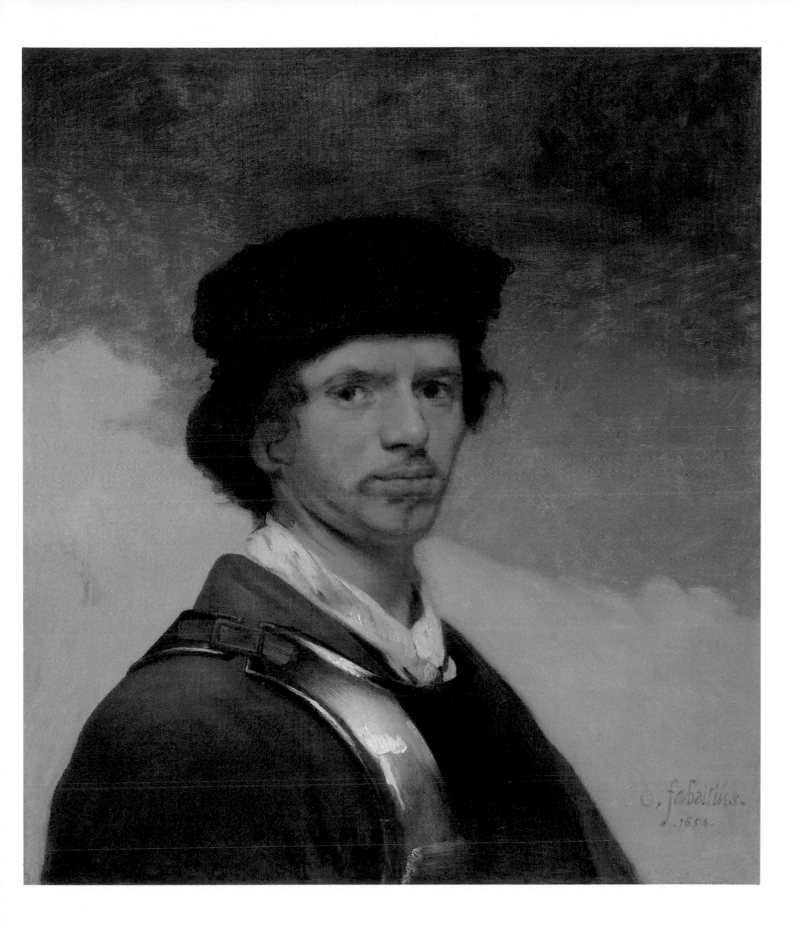

PLATE 13

Jan van Goyen, 1596–1656

A River Scene, with a Hut on an Island (No. 6154)

Oak, 37 × 33 cms
Signed, on the boat in the left foreground: VG (in monogram)
Bequeathed by Mrs C. S. Carstairs, 1952.

The town of Haarlem saw the development of naturalistic landscape painting in the early years of the seventeenth century. Two influential landscape painters (and print-makers), Hercules Segers and Esaias van de Velde, joined the artists' guild in the town in 1612, and in their work they gradually abandoned the mannerisms of the Flemish style which was their starting-point, evolving a more realistic account of landscape which was to culminate in the achievements of the greatest Haarlem landscape painter, Jacob van Ruisdael.

Jan van Goyen, who was born in Leiden, trained in the studio of Esaias van de Velde. In his earliest landscape (his first dated painting is from 1618) Van Goyen adopted the highly coloured, strongly linear technique of his master, but progressively the colour drained from his paintings and they became less crowded with figures. This move towards a deliberately restricted palette of blues, greys, greens and blacks, and simple compositions, Van Goyen shared with Pieter Molijn and Salomon van Ruysdael, Jacob's uncle, both of whom worked in Haarlem. In the work of all three painters, the sky comes to assume more and more importance until in a painting such as this one, which probably dates from the early 1640s, it occupies two-thirds of the paint surface. Van Goyen paints the clouds thinly – individual brushstrokes can be made out easily – over the prepared surface of the panel which provides a warm undertone. The features of the landscape itself, its buildings, boats and tiny figures, are outlined in black and then filled in with colour.

With this pronounced linear style it is no surprise to discover that Van Goyen was an indefatigable draftsman. Eight hundred drawings and several books of sketches survive, all executed in his favoured medium of charcoal with a little wash. Many are quick sketches from nature done during his frequent travels in the north Netherlands, and Van Goyen would have used such drawings in order to create landscapes like this one in the studio. A companion painting, also in the National Gallery, shows fishermen hauling in their nets.

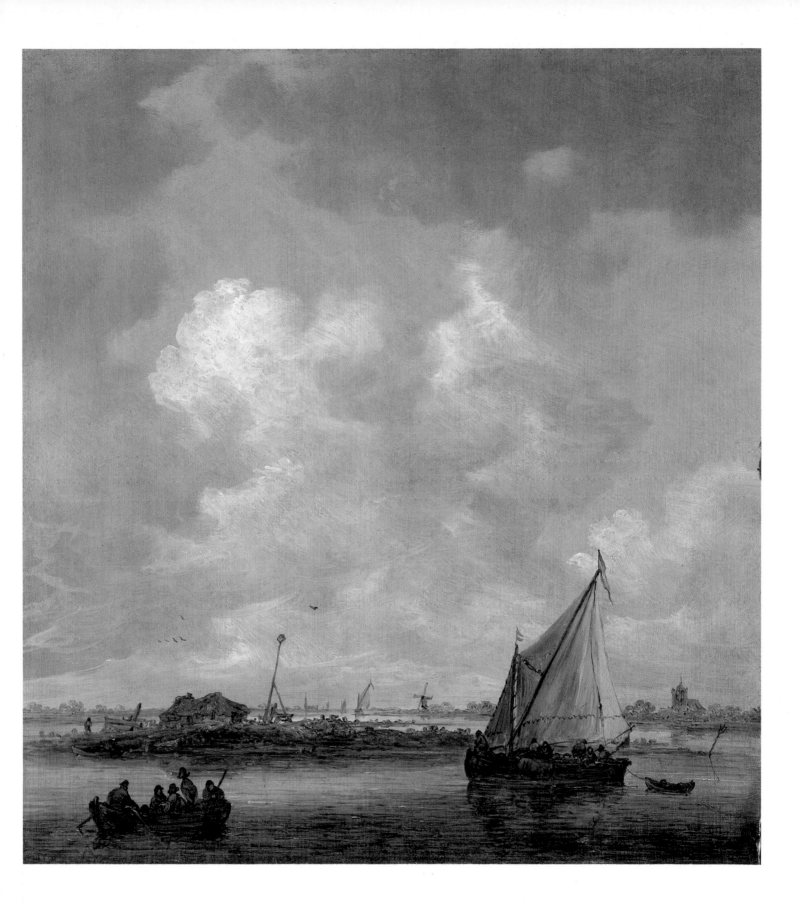

PLATE 14

Frans Hals, c. 1580–1666

A Family Group in a Landscape (No. 2285)

Canvas, 148.5 × 251 cms
Purchased, 1908.

The Dutch in the seventeenth century had a passion for portraiture: it has been said that we know more about their appearance than that of any society before the Victorians. They wished to have their features recorded in individual portraits, double portraits, family portraits and a variety of group portraits. Such was the demand that many Dutch painters derived their principal income from portraiture or exclusively painted portraits.

Frans Hals, who lived and worked in Haarlem, specialized in portraiture, although he also painted a small number of genre scenes. He is particularly known for his group portraits of the militia companies and the boards of regents and regentesses of the almshouse of Haarlem. His portraits are painted with an extraordinary vivacity of brushwork: here the light catches the edges of the collars, ruffs and sleeves in a series of darting white highlights. The heads are modelled in simple, flat planes enlivened by bold, individual strokes of a heavily-loaded brush. The result is to give the sitters a strong sense of immediacy, of real presence, which was greatly admired in the seventeenth century. The least important areas of the figures – the dresses of the women and the breeches and stockings of the men – are described in the most schematic manner, in a few slashing strokes.

The family has so far resisted all attempts at identification: the parents are seated in the centre while their seven children stand and play around them. They range from the eldest daughter on the right, who appears to be seventeen or eighteen, to the baby held by the maid on the far left. Especially poignant is the contrast between the still-vigorous father and his wife, who is prematurely aged by a constant succession of pregnancies.

The landscape background is not by Hals himself but by a specialist landscape painter, perhaps Pieter Molijn who, like Hals, worked in Haarlem.

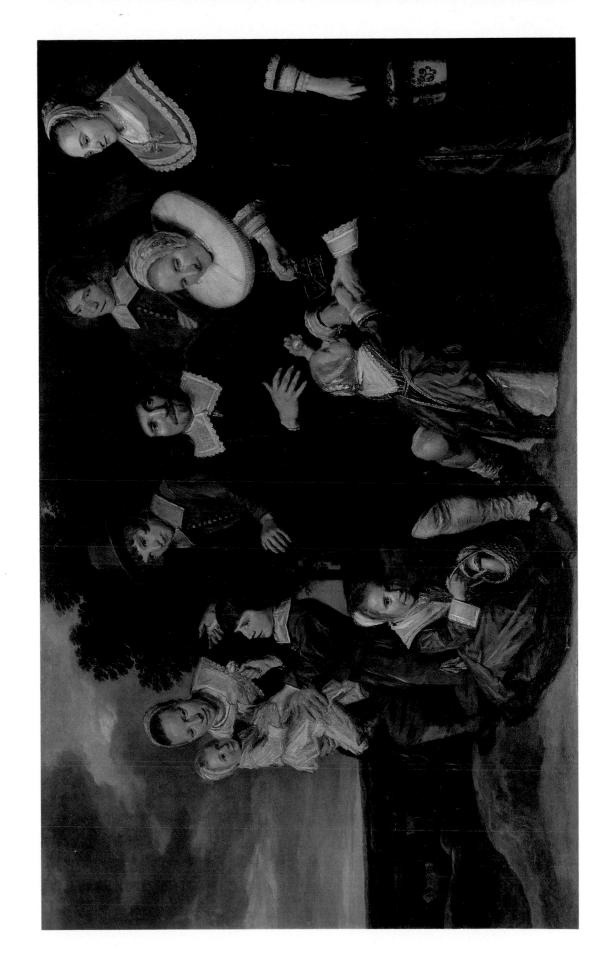

PLATE 15

Frans Hals, c. 1580–1666

Young Man holding a Skull (No. 6458)

Canvas, 92.2 × 80.8 cms
Purchased, 1980.

This outstanding example of Hals' bold, dramatic technique is, unusually in his work, not a portrait. It is a *vanitas*, that is, a reminder of the certainty of death; and as such it belongs to a Netherlandish tradition which goes back at least as far as an engraving of 1516 by Lucas van Leyden. It seems that this subject, even more than conventional portraiture, gave Hals the opportunity for a *bravura* display of his remarkable skill in conjuring up form in a few slashing brushstrokes. The hand which points out of the painting is particularly daring, a deliberate exercise in virtuosity. The boy's costume has little in common with the fashions of the day. The cloak thrown over his chest and the beret with its exaggeratedly long feather are of a theatrical type which the Dutch followers of Caravaggio used in their allegorical and genre paintings.

The picture must have been painted about 1626/8.

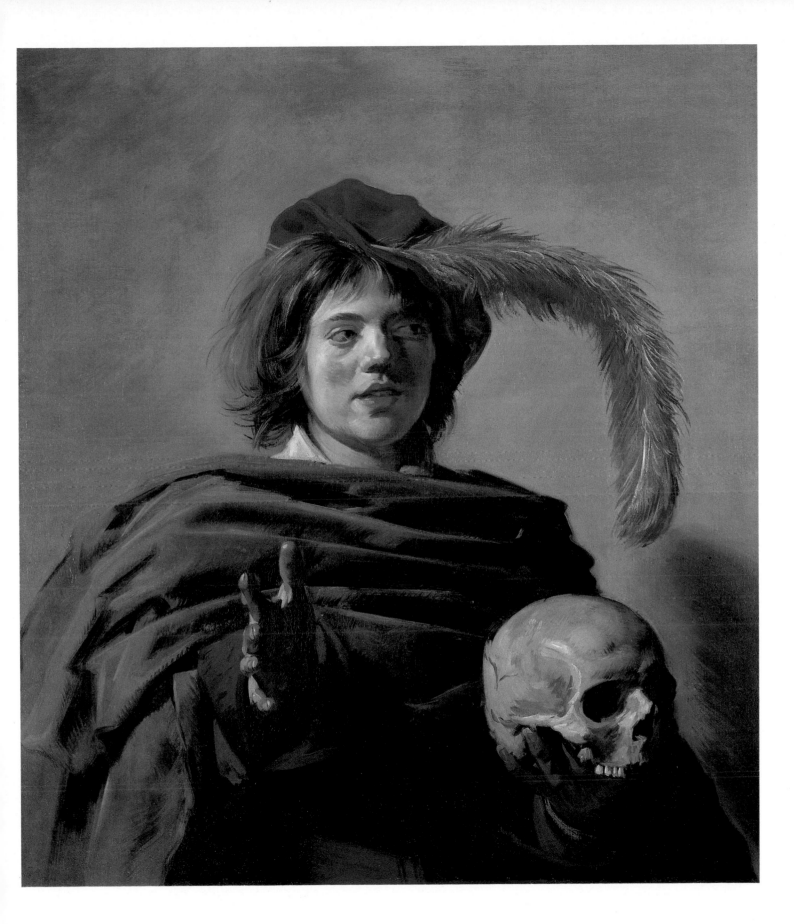

PLATE 16

Jan van der Heyden, 1637–1712

The Huis ten Bosch at The Hague (No. 1914)

Oak, 21.6 × 28.6 cms
Signed, on a stone at the bottom left, IVDH
Bequeathed by Sir James Morse Carmichael, Bart., 1902.

As has already been seen in Gerrit Berckheyde's view of the market square at Haarlem, Dutch painters proudly described the outstanding buildings and monuments of their country. The Huis ten Bosch, the 'House in the Wood', about a mile and a half east of The Hague, was among the most remarkable buildings erected in the north Netherlands during the seventeenth century. It was a small summer palace built between 1645 and 1652 for Amalia van Solms, wife of the Stadholder, Prince Frederik Henry of Orange, to the designs of the Dutch classical architect, Pieter Post. Of the remarkable campaign of palace-building undertaken during the Stadholdership of Frederik Henry only the Huis ten Bosch remains today. (The palaces of Rijswijck and Honselerdijk were both demolished in the nineteenth century.)

Van der Heyden's views of the Huis ten Bosch (he painted at least six others) are valuable evidence of its contemporary appearance. This painting dates from about 1670: it shows the building from the south or garden side. Subsequently an outer staircase was built on this side, the dome was altered and wings were added in the 1730s. The garden has been entirely destroyed and the prominent statues, elegant lattice, obelisks and carefully trimmed hedge, of which Van der Heyden makes such an effective pictorial element at the bottom edge of the painting, removed.

After Frederik Henry's death in 1652, Amalia van Solms transformed the just-completed Huis ten Bosch into a mausoleum for her husband. The principal room, the *Oranjezaal*, was decorated by a team of artists led by Jacob Jordaens from Antwerp with allegorical representations of Frederik Henry's career. This elaborate decorative scheme was devised by the artistic adviser to the Orange princes, Constantijn Huygens.

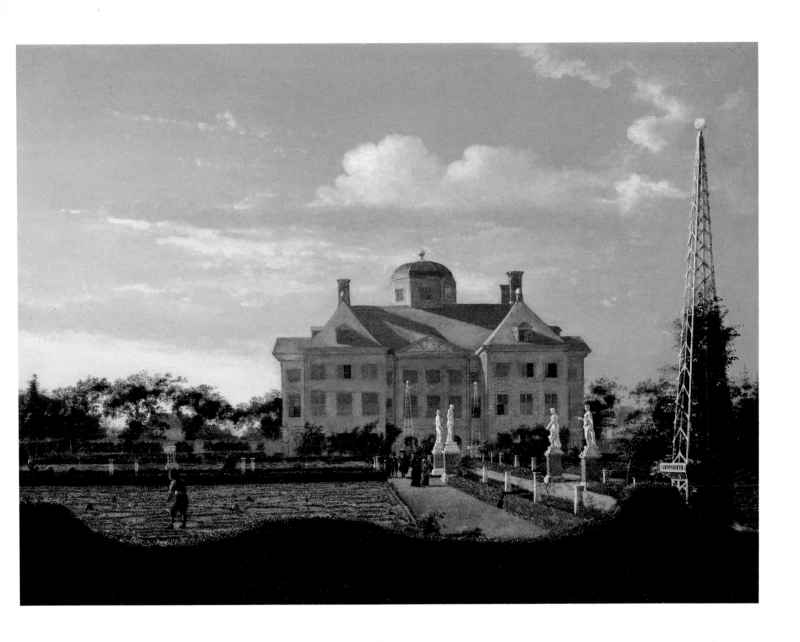

PLATE 17

Meindert Hobbema, 1638–1709

A Woody Landscape with a Cottage (No. 995)

Canvas, 99.5 × 130.5 cms
Wynn Ellis Bequest, 1876.

Meindert Hobbema, who was born in Amsterdam, was a pupil there of the Haarlem landscape painter Jacob van Ruisdael. Ruisdael had moved to Amsterdam by 1657 and Hobbema must have entered his studio soon after. Hobbema's technique in the depiction of landscape and his choice of forest scenes are derived from his master, but Hobbema's landscapes do not possess the grandeur or the threatening and even melancholy aspect of Ruisdael's. Hobbema's is a reassuringly docile vision of landscape, a town-dweller's account of the beauty of the countryside. It is an essentially decorative view, an anticipation of the Rococo landscapes of the eighteenth century.

This painting shows one of his favourite compositions, a forest scene with a clearing in the middle distance illuminated by a strong fall of sunlight, a picturesque farm building and a prominently placed group of figures. Hobbema repeated this composition in at least three other paintings: there are variations of size and small changes in detail but, like many other Dutch painters, Hobbema was quite happy to paint repetitions of particularly successful compositions.

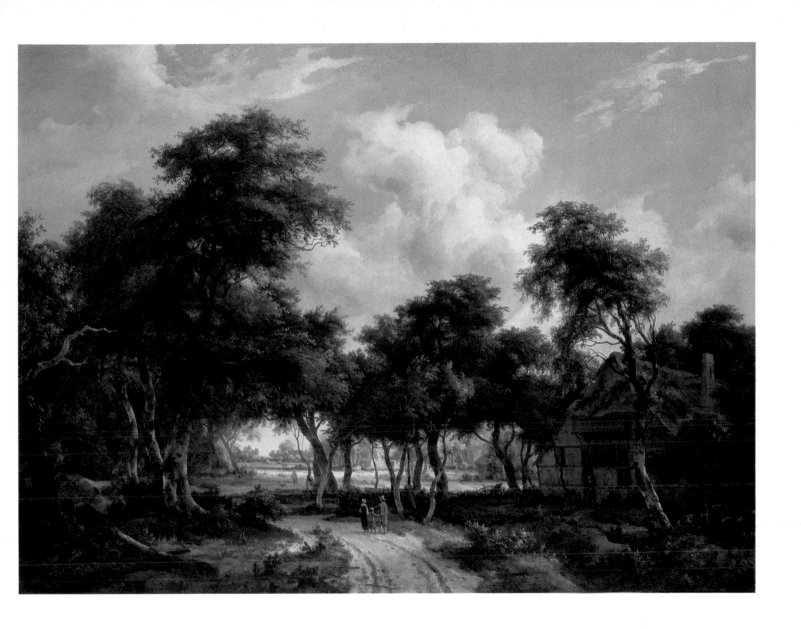

PLATE 18

Meindert Hobbema, 1638–1709

A View of the Haarlem Lock and the Herring Packers' Tower, Amsterdam (No. 6138)

Canvas, 77 × 98 cms
Signed, left, above the stern of the boat in the foreground, M hobbema
Bequeathed by Miss Beatrice Mildmay, 1953.

Although Hobbema specialized in forest scenes like the one on the previous page, he did paint a handful of views of actual places; the National Gallery has a painting of the ruins of Brederode Castle in addition to the famous *Avenue at Middel-harnis* (plate 19). This painting is the only town-scape by Hobbema. It shows the Haarlem Lock (*Haarlemmersluis*) and the Herring Packers' Tower (*Haaringspakkerstoren*) from the south west. The view is taken from the west end of the Singel canal where it meets the Brouwersgracht. None of the buildings seen in Hobbema's painting has sur-vived: the tower in the centre was pulled down in 1829.

It has been established that this was the view as it appeared in 1661: in the following year one of the smaller houses was demolished and replaced by a tall house with a stepped gable. This does not necessarily mean that the painting dates from before 1661 as Dutch view painters often based a composi-tion on a drawing made years earlier: the appeal of such paintings would have been nostalgic. Indeed, judging from the style, a date of about 1665 seems likely.

Hobbema's reason for choosing this part of Amsterdam for his only townscape may have been that by late in 1668 he was himself living in the Haarlemmerdijk, the corner of which can be seen in the painting on the right.

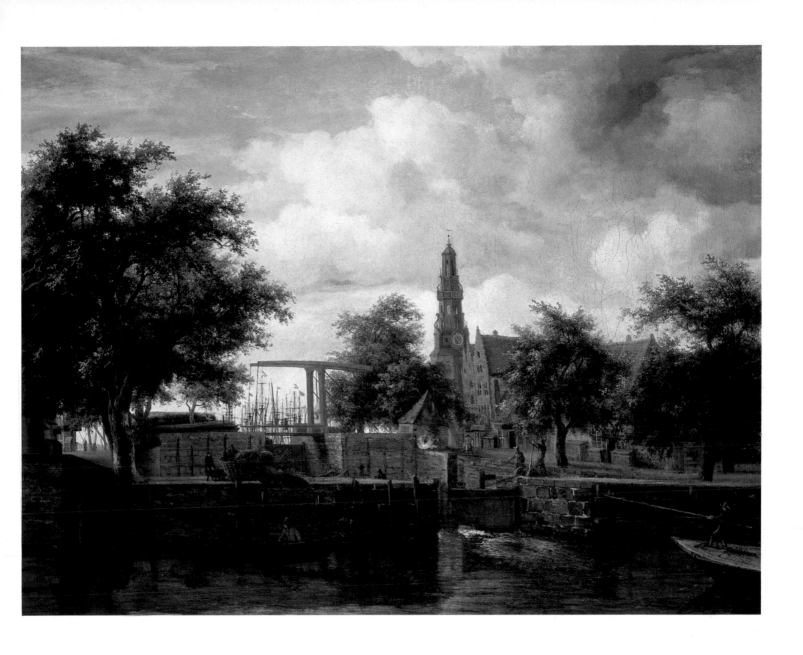

PLATE 19

Meindert Hobbema, 1638–1709

The Avenue at Middelharnis (No. 830)

Canvas, 103.5 × 141 cms
Signed, at the bottom right, M:hobbema/f 1689
Purchased with the Peel collection, 1871.

This picture, probably the most famous of all Dutch landscape paintings, is, in two important respects, an 'accidental' masterpiece. In the first place, it is most unlike the great majority of Hobbema's paintings which show sunlit forests. On a visit to southern Holland the artist was struck by the pictorial possibilities of this avenue of tall bare trees topped by bushy branches. They give the scene a remarkable central focus and effectively mark off the recession from foreground to background, the perennial problem of landscape painting. Secondly, the painting is dated 1689, twenty years after Hobbema gave up painting professionally. In 1668 he had been appointed, as a consequence of his marriage, one of the wine-gaugers of the Amsterdam wine importers' association, a post he held until his death. Thereafter Hobbema seems to have been a 'Sunday painter'.

It was perhaps the freedom granted to Hobbema by a well-paid job that enabled him to experiment with such an unconventional composition. (There can be no doubt that the relentless demands of the Dutch art market encouraged painters to repeat successful formulae.) Certainly the break with his usual forest scenes produced his greatest single painting. Sadly the sky is considerably damaged, probably by a nineteenth-century attempt at cleaning, and lacks much of its original subtlety: the billowing cloud on the right is the best preserved area.

For forty years, from 1782 until 1822, the painting hung in the Town Hall at Middelharnis. By 1834 it was in the collection of Sir Robert Peel, who owned an outstanding group of landscapes by Hobbema and his master, Jacob van Ruisdael.

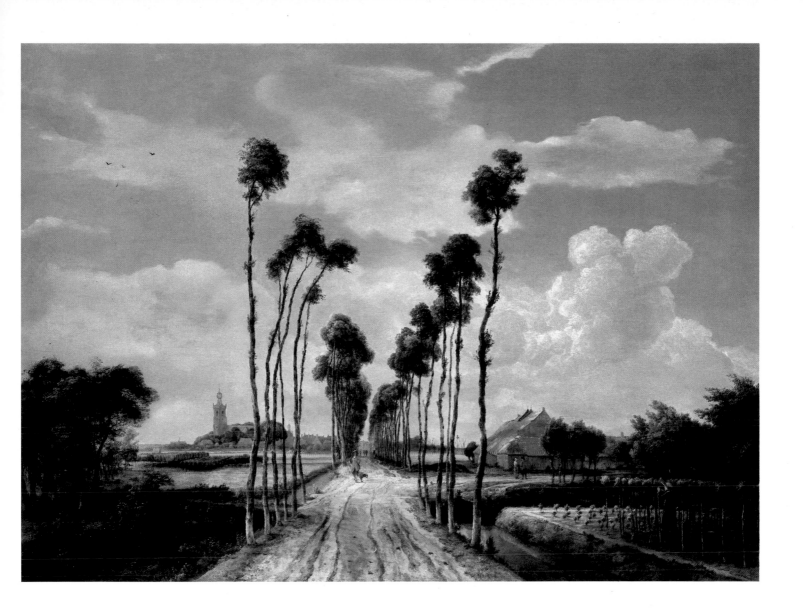

PLATE 20

Pieter de Hooch, 1629–1684

The Courtyard of a House in Delft (No. 835)

Canvas, 73.5 × 60 cms
Signed, left, at the base of the arch: P.D.H./An° 1658.
Purchased with the Peel collection, 1871.

This is one of the most perfectly judged of all Dutch genre paintings. The infinite subtlety of the composition, its apparent simplicity yet actual complexity, the balance between the foreground figures on the right and the woman standing in the passage on the left, the breath-taking painting of the wall on the right, the tenderness in the glance exchanged between the maid and the child – it is a painting in which it is impossible to imagine any element being different, or in a different place.

The paintings of De Hooch's Delft years evoke a world of quiet, domestic contentment, of pleasure taken in the performance of simple, household tasks, and in the appearance of well-ordered surroundings. It is an art which celebrates simple virtues, the efficient running of the home and the conscientious raising of children. The tablet above the arch in this painting was originally at the entrance to the Hieronymous cloister in Delft and today can be found set into the wall of no. 157, Oude Delft. Translated, it reads: 'This is in St Jerome's vale, if you wish to repair to patience and meekness. For we must first descend if we wish to be raised.' The inscription must have particularly appealed to De Hooch, for he used it again in another painting of the same year, 1658, with a similar composition. He employs it as a deliberate commentary on the painting and it is, of course, utterly appropriate to its tranquil mood.

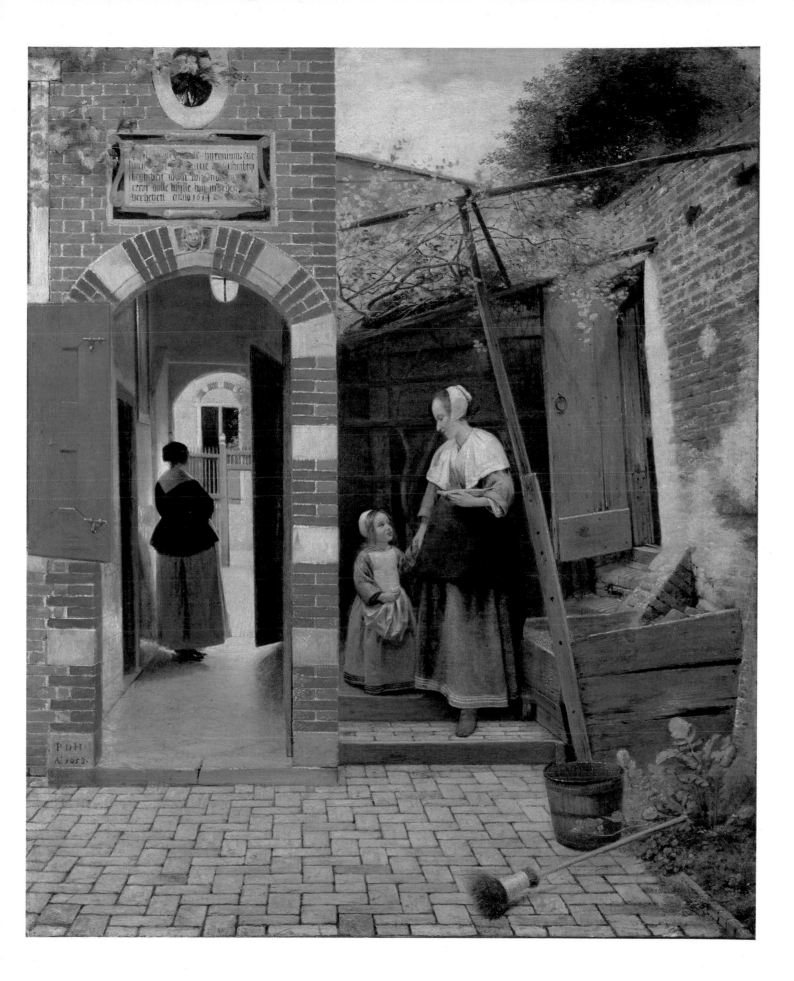

PLATE 21

Pieter de Hooch, 1629–1684

A Woman and her Maid in a Courtyard (No. 794)

Canvas, 73.7 × 102.6 cms
Signed, lower right: P.D.H./166(o?)
Purchased, 1869.

Pieter de Hooch was born in Rotterdam and is said to have been a pupil of the Italianate landscape painter Nicolaes Berchem in Haarlem. By 1653 he was in Delft and it was during his years in the town – he remained there until 1661, when he moved to Amsterdam – that he painted the series of subtle and restrained genre scenes on which his modern reputation is based.

De Hooch's Delft paintings are among the finest products of the so-called 'Delft school', the remarkable flowering of artistic talent in this small provincial town in the third quarter of the seventeenth century. Among the other leading artists of this group were Carel Fabritius and Johannes Vermeer.

The Delft painters shared an interest in the description of light and its daytime effects – for instance, the fall of sunlight on brickwork or through the thick glass of a window on to a plaster wall. They also explored the expressive possibilities of space – seen in this painting in the careful recession of the garden beyond the courtyard, through which strides a well-dressed man. He has just walked down a steep flight of steps from the old town wall. It is characteristic, too, of De Hooch's Delft paintings that the right edge of the picture should largely consist of an open door, a deliberately teasing *trompe l'oeil* element.

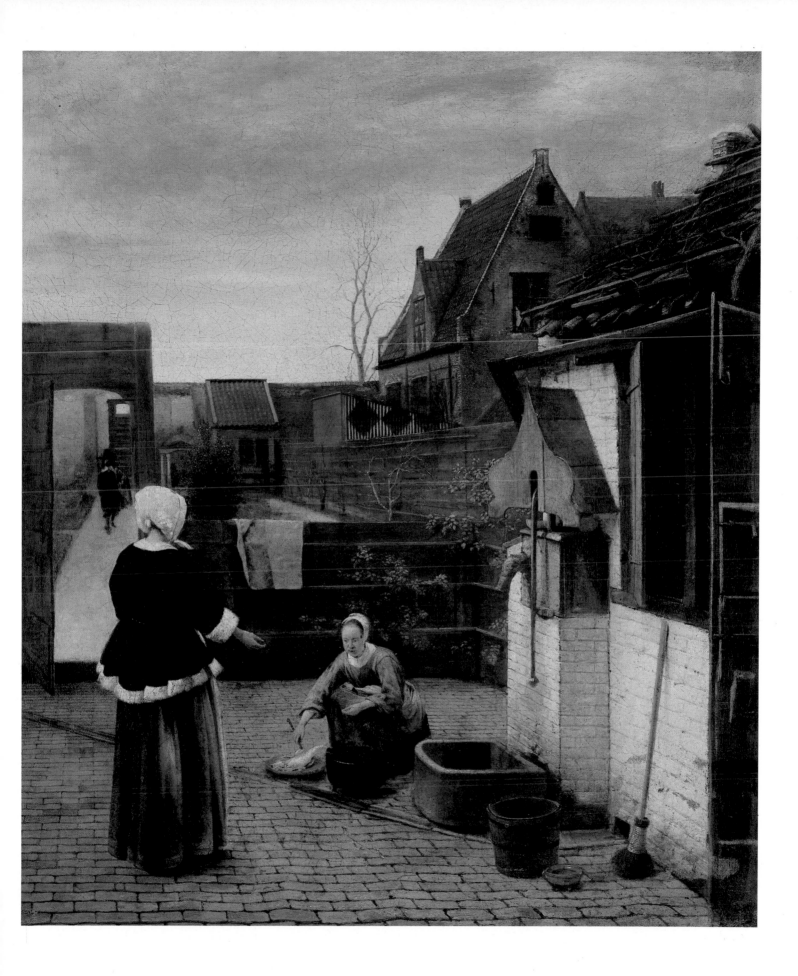

PLATE 22

Jan van Huysum, 1682–1749

Flowers in a Terracotta Vase (No. 796)

Canvas, 133.5 × 91.5 cms
Signed, on the ledge, bottom left, Jan Van Huijsum/fecit 1736/en 1737
Purchased, 1869.

Dutch painters described the visible world with remarkable exactitude and one of the forms this description took was the still-life. In the earliest years of the seventeenth century still-lifes often had a *vanitas* element: among the apparently casual collection of objects were clocks, snuffed-out candles, faded flowers and skulls, reminders of the passage of time and the inevitability of death and decay. As the century progressed these elements dropped away and still-lifes became simply displays of the rare, exotic, expensive and beautiful.

Jan van Huysum, whose career spanned the first half of the eighteenth century, was the heir to this great tradition of still-life painting and, as far as flower still-lifes are concerned, its greatest exponent.

This painting is one of his largest and most elaborate, an unashamedly exuberant *tour de force* of precise descriptive flower painting. The flowers, as is common in Van Huysum's pictures, are of different seasons. He apparently often delayed the completion of a painting until a particular flower was to bloom. This is the case here as we can see from the dates inscribed on the pedestal: the painting was begun in 1736 and completed in the following year. The steep perspective of the painting and the unusual shape of the canvas at the top make it likely that it was intended to be set into panelling above a mantelpiece, but its original location is unknown.

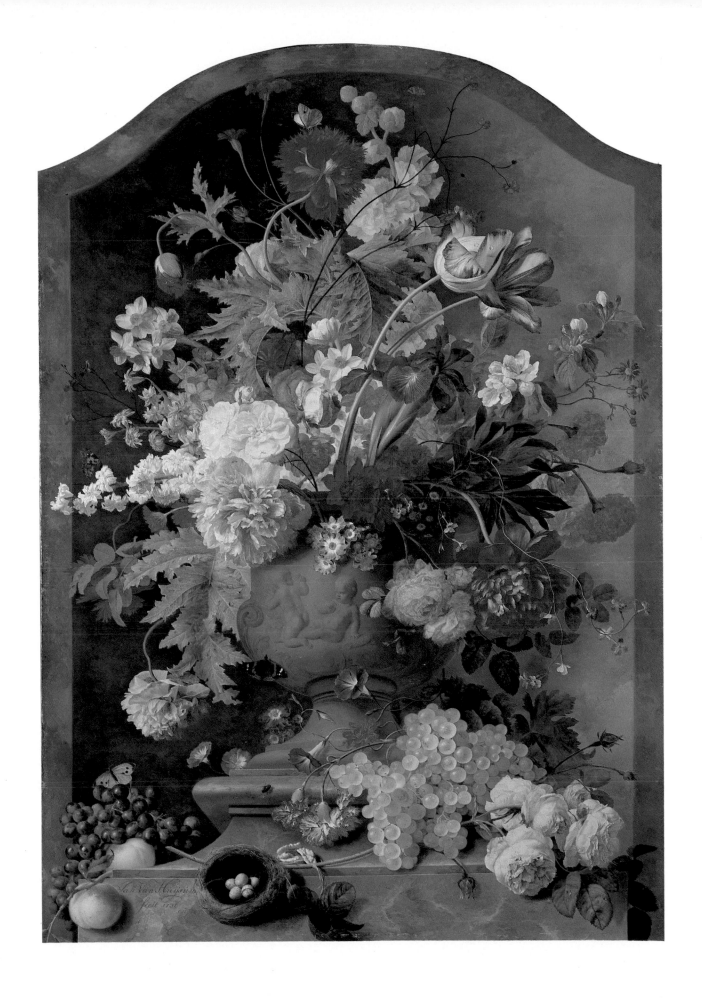

PLATE 23

Carel Dujardin, 1621/2–1678

Farm Animals in the Shade of a Tree, with a Boy and a Sleeping Herdswoman (No. 826)

Canvas, 34.6 × 39.7 cm
Signed, bottom right, K·DU·IARDIN·*fe.*/1656
Purchased with the Peel collection, 1871.

Dujardin, an Amsterdam painter, was a pupil of Nicolaes Berchem in Haarlem and, like Berchem, travelled to Italy when he had completed his training. Dujardin travelled in the Roman Campagna, as Berchem had done, making sketches of landscapes, animals and peasants, which rich material he used in the idealized Italianate views he painted on his return to the Netherlands.

This particular landscape contains the blue skies and hilly landscape of Dujardin's Italianate views, but in the detailed treatment of the animals and trees reveals his study of the precocious Paulus Potter, who had moved from The Hague to Amsterdam in 1652, four years before this picture was painted.

Although best known today for his paintings and etchings of landscapes and animals, Dujardin's subject matter was remarkably varied: among the National Gallery's six paintings by him are a *Self-Portrait* and a large-scale religious scene, *The Conversion of Saint Paul*, from 1662. Dujardin returned to Italy in 1675 and settled in Rome; he died in Venice three years later.

This painting was in the great eighteenth-century French collection of the Duc de Praslin. Brought to England to be sold in 1801, it was purchased in 1840 for Sir Robert Peel.

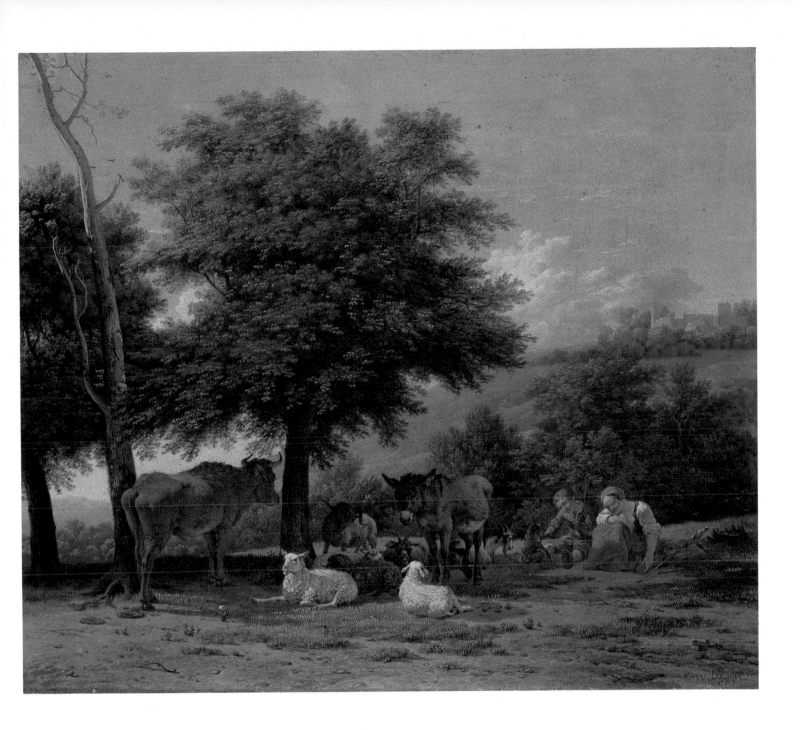

PLATE 24

Thomas de Keyser, 1596/7–1667

Portrait of Constantijn Huygens and his Clerk (No. 212)

Oak, 92.4 × 69.3 cms
Signed, on the front of the chimney-piece: TDK AN 1627 (TDK in monogram)
Richard Simmons Bequest, 1847.

Constantijn Huygens (1596–1687), who is identified by the coat of arms in the upper border of the tapestry behind him, was appointed secretary and artistic advisor to Prince Frederick Henry of Orange in 1625. He had previously served in the Dutch embassies in Venice and London, where he had been knighted by King James I. This portrait was painted in 1627, probably shortly before Huygens' marriage on 6 April.

Thomas de Keyser, son of the Amsterdam architect and sculptor Hendrick, was an extremely fashionable portrait painter at this moment, specializing in small-scale full-length portraits characterized by careful attention to detail. In this case De Keyser has indicated the sitter's wide interests by the inclusion of various objects placed on the table, which is covered by an elegant Ottoman carpet.

The *chittarone* (a long-necked lute) and the globes refer to Huygens' interests in music and astronomy. The plans on the papers appear to be architectural drawings which, together with the compasses, illustrate his interest in that art: Huygens worked closely with the architect, Pieter Post, on the Orange palace, the Huis ten Bosch, and on the plans for his own house in The Hague.

Huygens had a great interest in the visual arts and was largely responsible for the House of Orange's patronage of the arts. It is a tribute to his keeness of eye that he was among the earliest admirers of Rembrandt, when the artist was still in Leiden, and persuaded the Prince of Orange to commission an important series of paintings representing the Passion from the young painter in the 1630s.

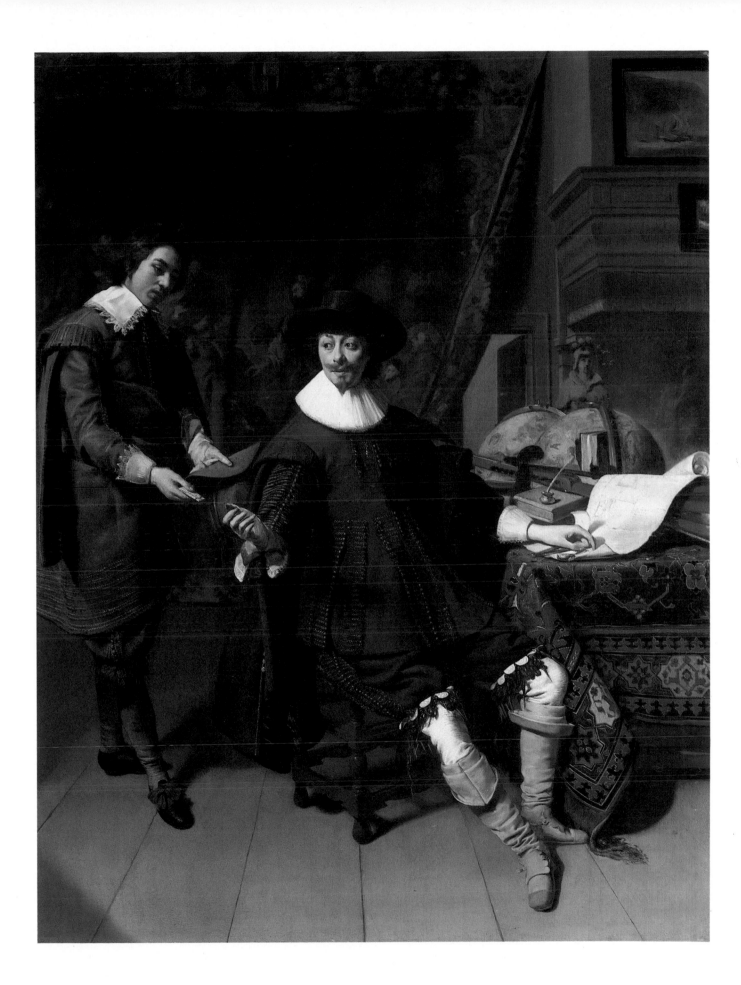

PLATE 25

Philips Koninck, 1619–1688

An Extensive Landscape with a Road by a Ruin (No. 6398)

Canvas, 137.4 × 167.3 cms
Signed, lower right, P Koninck 1655
Acquired, 1971.

His contemporaries knew Philips Koninck as a figure painter, specializing in portraits as well as genre and religious scenes, rather than as a landscapist as he is best known today. He was born in Amsterdam, the son of a successful goldsmith, and studied with his brother Jacob, a painter in Rotterdam. Subsequently he returned to Amsterdam where he lived for the rest of his life. An early biographer records that he was a pupil of Rembrandt, but this is unlikely. He probably knew Rembrandt, however, and was certainly influenced by his manner of painting (and drawing) religious subjects. Koninck was a wealthy man, owning a company operating *trekschuiten* (horse-drawn barges) between Rotterdam and Amsterdam.

Koninck's landscapes are almost all characterized by a high viewpoint and a sky which occupies at least half of the picture space. He emphasizes the flatness of Holland, a more realistic approach than, for example, that of Albert Cuyp, who attempts to make his landscapes more varied by the inclusion of hills and mountains taken from his imagination rather than from his observation of the Dutch countryside. The landscape with a high sky was particularly in favour in the 1650s and 1660s, not just in the work of Koninck, but that of Jacob van Ruisdael and also in the etched landscapes of Rembrandt.

Koninck's technique in representing extensive landscapes is based very firmly on careful study of his native countryside. The foreground he paints in a broad, even rough manner, whereas the middle ground is represented in considerable detail and the background with free strokes of colour. This accords well with the manner in which the eye sees a flat landscape, focusing on the middle ground while the foreground and the distance are glimpsed in a blur of colour. In this way Koninck brilliantly solves the prennial problem of painting landscape, recession into the far distance: in this particular canvas he further binds the composition together by the device of a road leading the eye through the picture.

This painting is an outstanding example of Koninck's landscape art. The colours, which in some of his canvases have with the passage of time sunk into uniform browns and greys, are particularly vivid and the painting is remarkably well preserved.

PLATE 26

Nicolaes Maes, 1634–1693

Interior with a Sleeping Maid and her Mistress (No. 207)

Oak, 70 × 53.3 cms
Signed, bottom right, N.MAES. 1655. (MAE in monogram)
Richard Simmons Bequest, 1847.

Maes, who was born in Dordrecht, was a pupil in Rembrandt's Amsterdam studio in the years around 1650. His earliest biographer wrote that he soon abandoned Rembrandt's manner of painting when he returned to Dordrecht, and this is confirmed by his surviving paintings. There are a number of large Rembrandtesque religious paintings attributed to him which were presumably painted immediately after he left the studio – the *Christ Blessing the Children* in the National Gallery is one – but soon he was concentrating on small-scale genre paintings like this one. He continued to explore genre subjects during the 1650s, but after 1660 confined himself exclusively to portraiture.

Maes' domestic interiors often deal with the life of servants and their relationship to their employers. It is a theme he shares with Pieter de Hooch, and there may well have been some contact between the two painters – Delft and Dordrecht are not far apart. In this painting the mistress of the house, who has stepped down from the front room (facing on to the street in the usual Dutch arrangement), invites our indulgence and amusement at the sight of the maid who has fallen asleep over the unwashed dishes and pots. While she has slept a cat has jumped up on to a cupboard and is stealing food. The maid's pose is a traditional one to represent *acedia* or idleness, one of the seven deadly sins, and yet it is hard to believe that the mistress's smile and gesture indicate severe moral condemnation.

Maes, like de Hooch, Carel Fabritius and Vermeer, was interested in perspective and the depiction of interior space. This painting appears to be the earliest Dutch genre scene to show a view through into a far room (known in Dutch as a *doorkijkje*) which was to be much used by later artists to add depth and animation to domestic interiors.

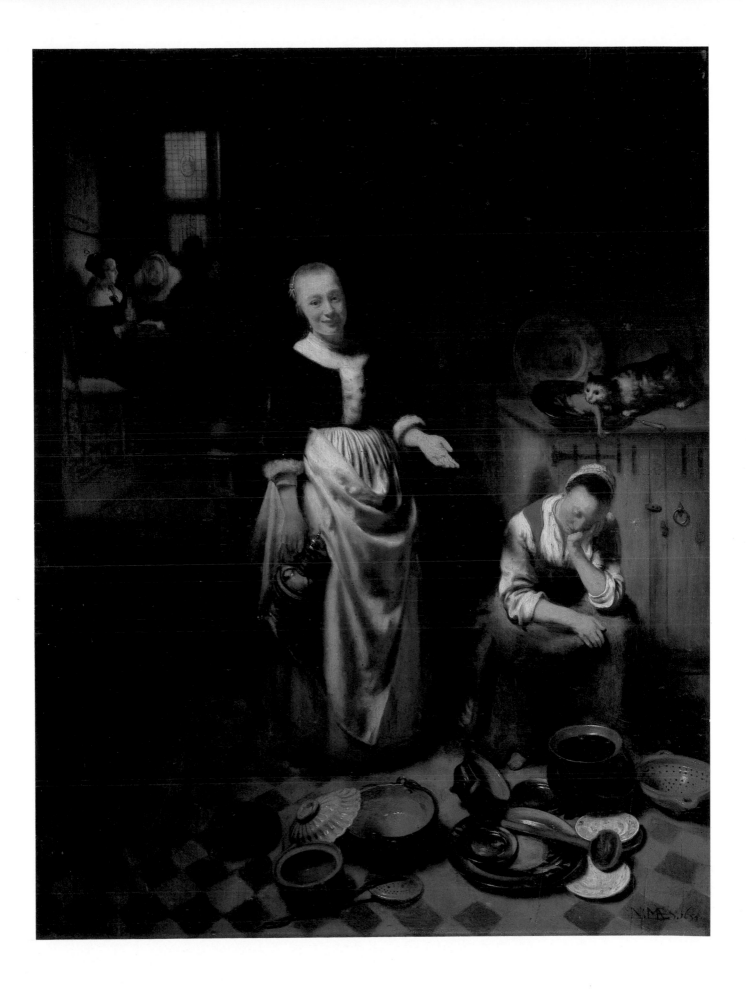

PLATE 27

Gabriel Metsu, 1629–1667

A Man and a Woman seated by a Virginal (No. 839)

Oak, 38.4 × 32.2 cms
Signed, top right, G. Metsu
Purchased with the Peel collection, 1871.

Metsu, a native of Leiden, is said to have been a pupil of Gerrit Dou, and his earliest paintings reveal a meticulousness of detail which is no doubt a consequence of his training. After his move to Amsterdam in 1657, however, his style becomes far broader, the forms being modelled in light, shadow and colour rather than in fine descriptive detail. This particular painting probably dates from a few years after Metsu's arrival in Amsterdam, and it reveals his exceptional sensitivity as a colourist.

Hanging in an ornate gold frame in the background and covered (as was usual in Dutch houses of the period) by a curtain we find a painting of *The Twelfth Night Feast*, a rowdy scene of revelry very similar in composition to a treatment of this subject by Metsu himself which today is in the Alte Pinakothek at Munich. By including the picture, Metsu is referring to an earlier phase of his career when he painted a number of large-scale figure paintings in a style similar to that of the followers of Caravaggio in Utrecht.

In Dutch genre painting, music and love are often associated. In this case, the young woman is giving the man a sheet of music so that he can take up his violin and accompany her in a duet, which represents the harmony of love. In return he offers her a glass of wine. The lid of the virginal at which the young woman sits bears two inscriptions, both from the Psalms: 'In thee Lord do I put my trust; let me never be ashamed', and 'Let everything that hath breath praise the Lord'. The presence of the inscriptions in a painting whose theme is love would seem to be deliberately ironic.

The same virginal can be seen in other paintings by Metsu and it may have been an actual instrument owned by the painter; it is very similar to those made by the famous craftsman, Andries Rucker the Elder, in Antwerp in around 1620.

PLATE 28

Frans van Mieris the Elder, 1635–1681

A Woman in a Red Jacket feeding a Parrot (No. 840)

Copper, 22.5 × 17.3 cms
Purchased with the Peel collection, 1871.

Gerrit Dou called Frans van Mieris 'the Prince of my pupils'. Van Mieris was the son of a Leiden goldsmith and, like Dou himself, had been trained in the studio of a glass-painter before entering that of a painter. Van Mieris mastered Dou's highly finished technique and after his master's death was the leading exponent of the *fijnschilder* ('fine painter') style. He spent his entire working life in Leiden, although (again like Dou) he enjoyed a considerable international reputation; in particular, he received commissions from Duke Cosimo de' Medici.

Like his master, Van Mieris painted on a small scale and on supports – oak or copper – which enabled him to create a very high degree of finish. This copper panel is an excellent example of his remarkably fine technique: the elaboration of detail can be seen in the creases of the velvet wrap, the ringlets of the woman's hair, her ribbons, the parrot's plumage and the stitching on the edge of the chair. It is one of three versions of this composition, all by Van Mieris himself: such repetition, which Dutch artists did not consider inimical to creativity (as Italian artists might have), is a striking feature of Dutch seventeenth-century painting as a whole.

This painting has had a distinguished history. It was in a French collection, that of L J Gaignat, by 1760 and subsequently in that of Prince de Talleyrand. It was later owned by William Beckford and, like Dou's *A Poulterer's Shop* (plate 7), was purchased at the Fonthill Abbey sale of 1823 for Sir Robert Peel.

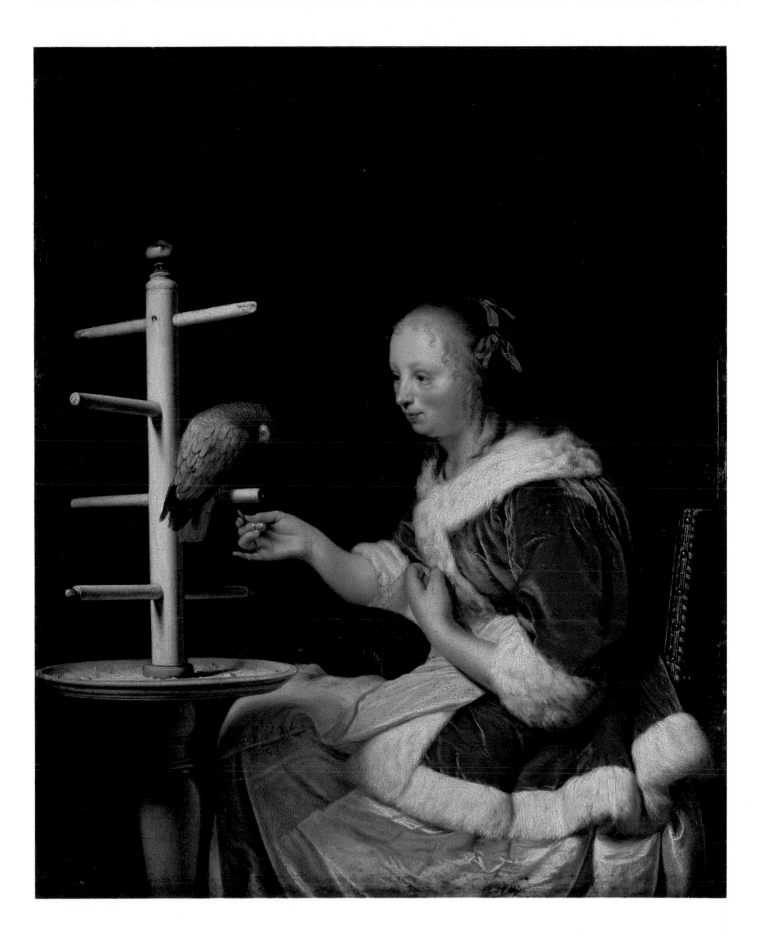

PLATE 29

Isack van Ostade, 1621–1649

A Winter Scene, with an Inn by a Frozen Stream (No. 963)

Oak, 48.8 × 40 cms
Purchased with the Peel collection, 1871.

Isack was the short-lived younger brother of Adriaen van Ostade, who is known for his scenes of peasant life. Isack was a pupil of his brother and his earliest paintings – of which there is an example in the National Gallery – are peasant interiors dependent on Adriaen's. Towards the end of his brief career – his earliest dated picture is from 1639 – he became more interested in outdoor scenes, often set in winter. This deliberately picturesque scene, its low viewpoint having the effect of outlining the wooden bridge against the sky, is one of his finest paintings. It is rich in its treatment of the detail of peasant life, whose harsh aspects (as in the man labouring under his load of faggots) are relieved by the pleasure taken by the child in the anticipation of skating on the frozen river.

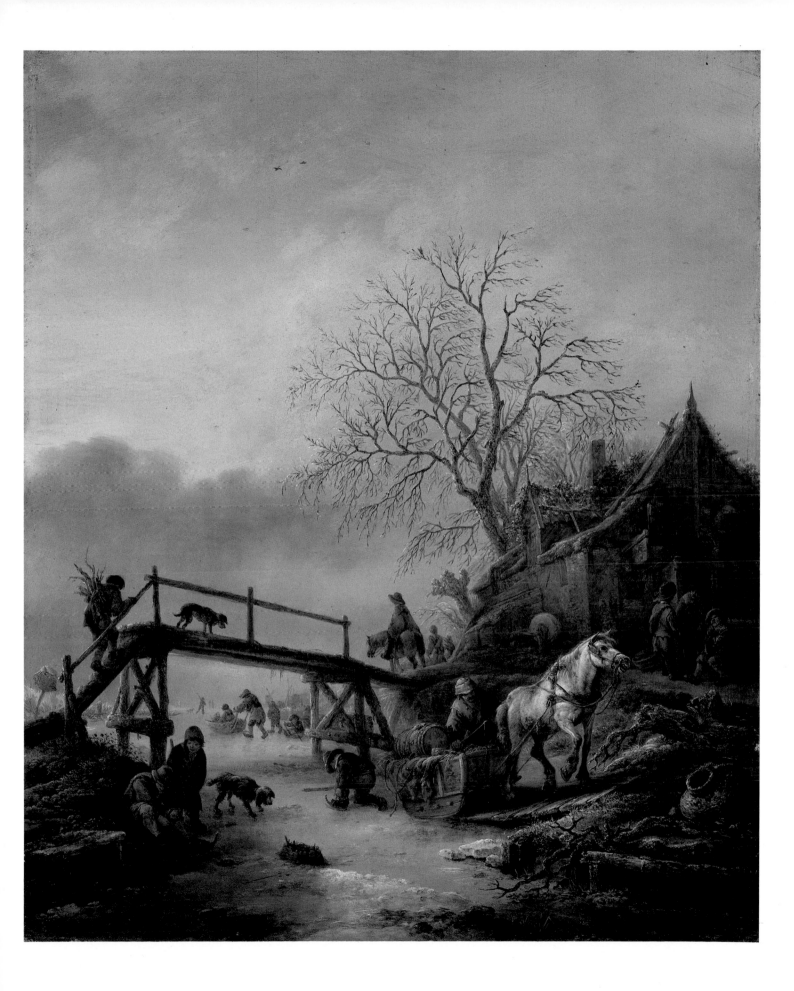

PLATE 30

Paulus Potter, 1625–1654

A Landscape with Cows, Sheep and Horses by a Barn (No. 849)

Oak, 57.7 × 53.9 cms
Signed, on the tree trunk in the centre foreground: Paulus.Potter. f. 1651.
Purchased with the Peel collection, 1871.

Potter, the son of a painter, was a prodigy. During a very short working career – he died at the age of twenty-nine – he painted a large number of landscapes with animals and exercised an important influence on the development of the subject in the Netherlands. The landscapes of Karel Dujardin, for example, who was three years Potter's senior, were profoundly affected by study of the younger man's work. Potter's landscapes are strongly, almost obsessively, realistic, painted in fine detail but with the use of carefully modulated aerial perspective to indicate recession.

Potter found an enthusiastic patron in Dr Nicolas Tulp, the wealthy Amsterdam surgeon whose 'Anatomy Lesson' had been painted by Rembrandt in 1632. It seems to have been Tulp who persuaded Potter to move from The Hague to Amsterdam in 1652; Potter painted an equestrian portrait of Tulp's son Dirk in the following year. Potter was a devout Calvinist, which presumably accounts for his specialization as a landscape painter: he never attempted any religious figure subjects of the type associated with Rembrandt and his school.

Potter's fame stood very high in the first half of the nineteenth century when his unnervingly naturalistic *Young Bull* in the Mauritshuis, a huge canvas painted in minute detail, was the best known and most widely admired of all Dutch paintings.

This landscape, which is first recorded as fetching a very high price at auction in Amsterdam in 1756, was in Peel's collection.

PLATE 31

Rembrandt van Rijn, 1606–1669

Saskia van Uylenburch in Arcadian Costume (No. 4930)

Canvas, 123.5 × 97.5 cms
Below, on the left, are the remains of a signature and date: Rembrandt/1635.
Purchased, 1938.

Rembrandt moved from his native Leiden to Amsterdam in the winter of 1631/2 at the instigation of Gerrit van Uylenburch, a leading art dealer in the city. On his arrival he lived in Van Uylenburch's house in the Sintanthonisbreestraat and in 1634 the painter married his host's cousin, Saskia. The daughter of a wealthy family from Leeuwarden in Friesland, she brought him a large dowry and there can be no doubt that the marriage represented social advancement for the successful young painter. In 1635, the year after his marriage, Rembrandt showed his wife in this portrait as the Roman goddess of spring, Flora. In choosing this guise he was reflecting the contemporary vogue in Amsterdam for Arcadian and rustic dress. This pastoral mode, which is not unlike Marie Antoinette's passion for dressing up as a shepherdess, had become enormously popular in the city following the success of a play by P. C. Hooft, *Granida en Daifilo*, which celebrates the joys of country life.

In showing his young wife in the guise of the goddess Flora, Rembrandt employed a scale, composition and even technique which owe much to his study of the Netherlandish followers of Caravaggio. The portrait has much in common with a group of pictures of religious subjects which Rembrandt painted in the second half of the 1630s, among them the *Belshazzar's Feast* in the National Gallery. For both, Rembrandt used the same large-scale, monumental figures in relation to the total picture space, strong falls of light, rich colours, passages of intricate detail (as in Saskia's embroidered bodice) and the device of making the figures stand out by painting them in light tones against a dark background.

Saskia was to die, weakened by many pregnancies, in June 1642 and was buried in the Westerkerk. Of the couple's children only Titus, a sickly boy who was himself to die at the age of twenty, was alive at the time of her death.

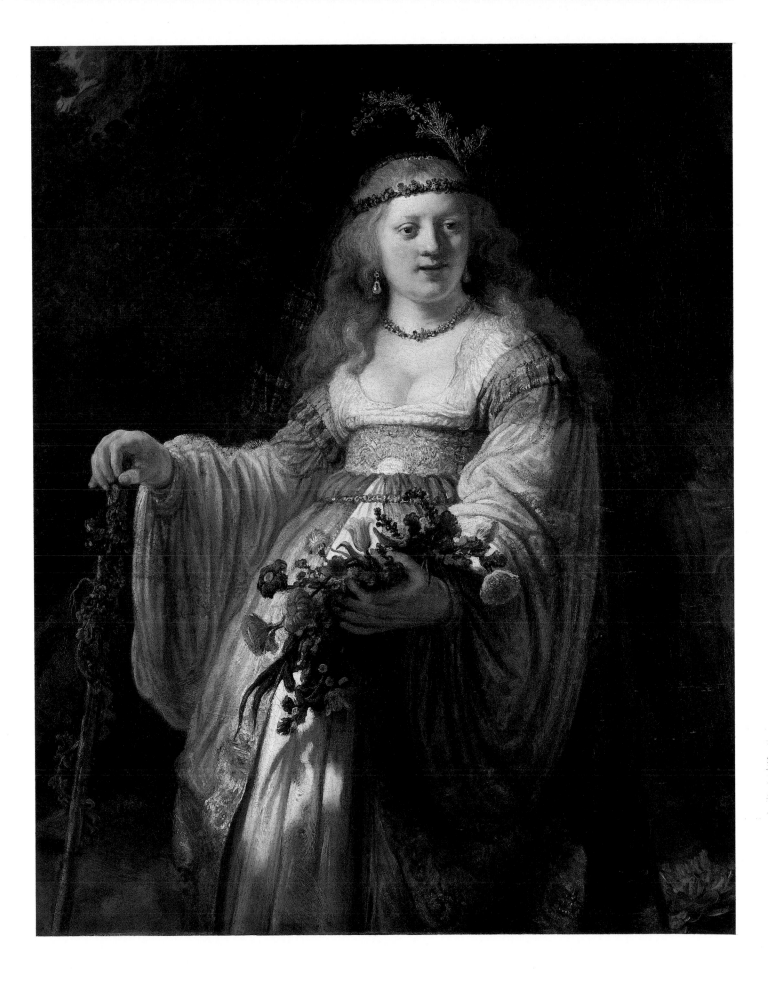

PLATE 32

Rembrandt van Rijn, 1606–1669

Self-Portrait at the Age of 34 (No. 672)

Canvas, 102 × 80 cms

Signed, on the sill, bottom right: Rembrandt. f. 1640. Written beneath the signature and date is the word *Conterfeycel* (portrait)

Purchased, 1861.

In 1640 Rembrandt was one of the leading painters in Amsterdam. He was wealthy, successful and confident, and this is how he presents himself in this self-portrait of that year. He is dressed in velvets and furs, a jewel in his cap and a gold chain across his chest. It has long been recognized that Rembrandt's pose is based on two Italian High Renaissance portraits, Raphael's *Portrait of Baldassare Castiglione* today in the Louvre, and Titian's *Portrait of a Man with a Blue Sleeve*, now in the National Gallery which in the seventeenth century was thought to show the poet Ludovico Ariosto. Both these paintings had been sold in Amsterdam in 1639 and Rembrandt had sketched the *Castiglione* at the auction. They were bought by a Portuguese merchant, Alfonso Lopez, who lived in the city and also owned paintings by Rembrandt. The Titian was Rembrandt's more important model: it was the source for the parapet, the prominence of the sleeve, and the position of the body.

There is probably another reason why Rembrandt chose to follow the Titian so closely. It seems that in painting himself in the guise of a great Italian Renaissance poet, Rembrandt was implicitly placing his own art, painting, on a par with the traditionally far more elevated art of poetry. In this way he would have been participating in the debate, which may seem obscure today but which was a real one in the Renaissance and later, about the relative importance of the various arts. Rembrandt was conscious that, despite his considerable material success, he did not command the social position of painters in Italy, or, for that matter, in nearby Flanders. In one sense, therefore, the Self-Portrait may be seen as a plea for higher status to be given to painters and painting in Holland.

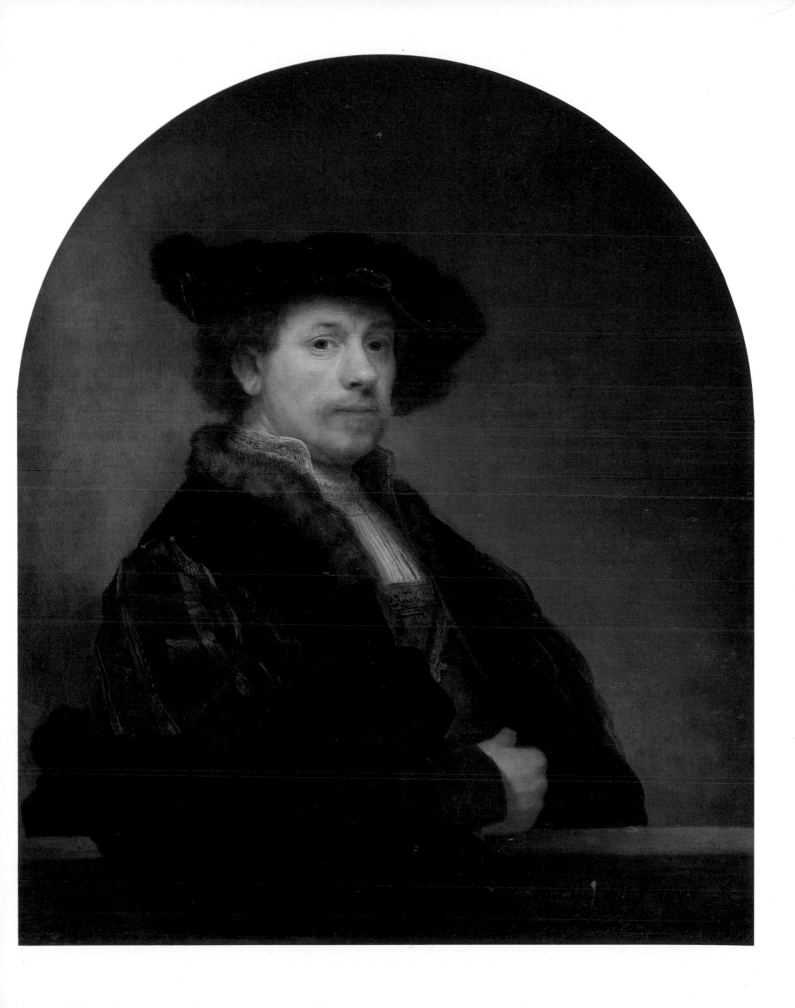

PLATE 33

Rembrandt van Rijn, 1606–1669

The Woman taken in Adultery (No. 45)

Oak, 83.8 × 65.4 cms
Signed, bottom right: Rembrandt f. 1644
Purchased, 1824.

Christ's forgiveness of the adulteress is described in the Gospel of St John, Chapter 8. Rembrandt shows the moment at which the Pharisees, attempting to outwit Christ, ask him whether, according to the law of Moses, she should be stoned. He replies, 'He that is without sin among you, let him cast the first stone.'

This painting is an outstanding example of Rembrandt's gifts as a colourist, an aspect of his art which is often forgotten. It is in some respects an unusual painting for its date, 1644, in that the composition – the small figures dwarfed by the cavernous interior of the temple – as well as the elaboration of detail and the degree of finish, especially in the background, hark back to paintings of a decade earlier. However, the broader treatment of the foreground figures is consistent with Rembrandt's greater freedom of handling in the 1640s and, above all, the quieter, restrained mood of the picture accords with a move away from the intensely dramatic Biblical scenes of a few years before. The painting can be viewed as one of the first of Rembrandt's maturity.

The painting has had an interesting history. It was almost certainly the picture of this subject which, at 1500 guilders, was the highest valued item in the inventory of the Amsterdam dealer, Johannes de Renialme, drawn up in 1657. Subsequently, it was owned by the Six family until it was sold to a dealer in 1803. Four years later it was sold in London to John Julius Angerstein, whose paintings, purchased by the Government in 1824, formed the basis of the National Gallery collection.

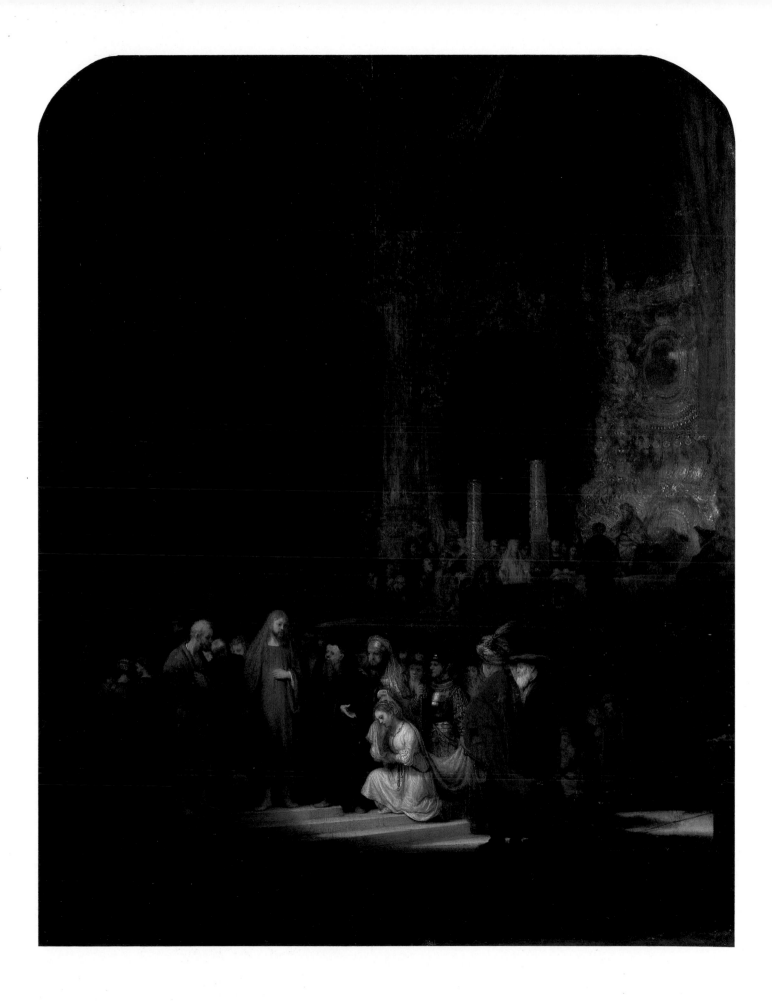

PLATE 34

Rembrandt van Rijn, 1606–1669

A Woman Bathing in a Stream (No. 54)

Oak, 61.8 × 47 cms
Signed, on the bank, bottom left: Rembrandt f 1654
Bequeathed by the Reverend Holwell-Carr, 1831.

The model for this figure was probably Rembrandt's mistress, Hendrickje Stoffels. There is no securely identified portrait of her, as there is of his wife Saskia (who died in 1642) but a group of studies from the years when she was living with the painter shows the same sitter and the tenderness with which they are painted makes it most likely that they show Hendrickje. Born in 1625 or 1626, Hendrickje Stoffels had entered Rembrandt's household as a nurse for his young son Titus by 1649. In 1654 – the year of this painting – she was admonished by the council of the Reformed Church for living in sin with the painter, and later that year she bore him a daughter, Cornelia. She remained with Rembrandt until her death in 1663.

In this small painting on panel the rich gold and red robe abandoned on the river bank suggests that it is a sketch for a religious or mythological composition. The bathing woman may be meant for Susannah, though the lustful elders are nowhere to be seen; or the goddess Diana bathing, though her usual attendants are absent. The picture has the free handling appropriate to a sketch; the paint is firmly applied with broad strokes of a fully loaded brush.

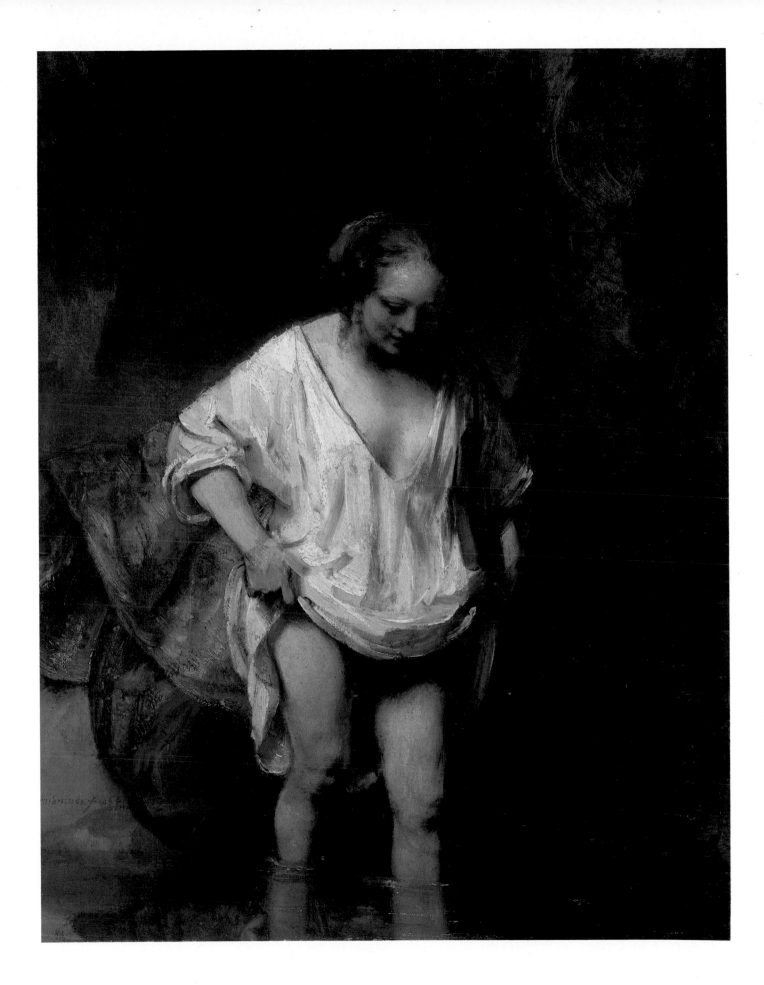

PLATES 35 AND 36 (OVERLEAF)

Rembrandt van Rijn, 1606–1669

Portrait of Jacob Trip (1575–1661) (No. 1674)

Canvas, 130.5 × 97 cms

Signed, on the right, a little above the level of the sitter's left hand: *Rembr.*

The canvas has been cut down by about two inches on the right, thereby removing the final letters of the signature.

Portrait of Margaretha de Geer (1568–1672), wife of Jacob Trip (1675)

Canvas, 130.5 × 97.5 cms

Purchased, 1889.

Jacob Trip and his wife, Margaretha de Geer, seem to have sat to Rembrandt for this pair of monumental three-quarter-length portraits in 1661. Jacob Trip died in May that year, when the portraits may still have been unfinished. The Trips were one of the leading families of the United Provinces. Jacob, the patriarch, was a Dordrecht merchant who in 1603 had married the daughter of Louis de Geer, a wealthy ironmaster and arms dealer. With his brother-in-law Louis the Younger, Jacob built up an immense fortune selling arms to both sides in the English civil war and in wars in the Baltic. Jacob and Margaretha's sons, Louis and Hendrick, moved from Dordrecht to Amsterdam, and built the Trippenhuis, a grand classical mansion on the Kloveniersburgwal. The house was being built between 1660 and 1662, and it therefore seems possible that these portraits were intended to hang in its ornate interior.

Jacob and Margaretha came to Amsterdam to sit to Rembrandt rather than being painted in Dordrecht by a local painter like Nicolaes Maes. Maes had painted their portraits a few years earlier and the comparison makes the power of Rembrandt's portraits particularly evident. Those by Maes are bland and competent while the Rembrandts are vivid and lively, the paint applied in visible dabs and strokes.

Much of the toughness, determination and puritanism of the founders of the great prosperity of the Dutch Republic in the seventeenth century can be detected in these portraits. The faces of the two old people are uncompromisingly severe, and it is on the faces that Rembrandt concentrates. The backgrounds are formless, the chairs only suggested and the clothes sketched in the simplest way. Rembrandt focuses the spectator's attention on the two remarkable heads, which are heavily worked with a combination of firm and light brushstrokes. Only one other feature stands out – the hands, notably those of Margaretha. In both portraits one hand is occupied – Jacob's with his stick and Margaretha's hand in clutching a white handkerchief. The other, in Jacob's portrait, is laid on his lap, while Margaretha's left hand is curled around the armrest of her chair, knuckles facing outwards.

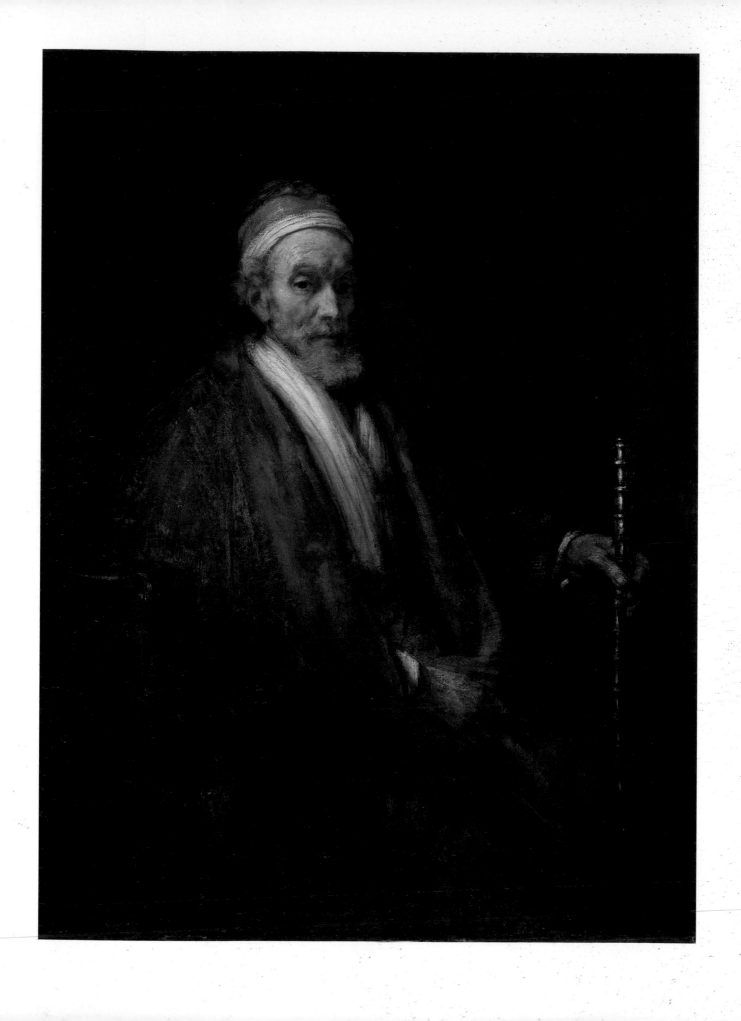

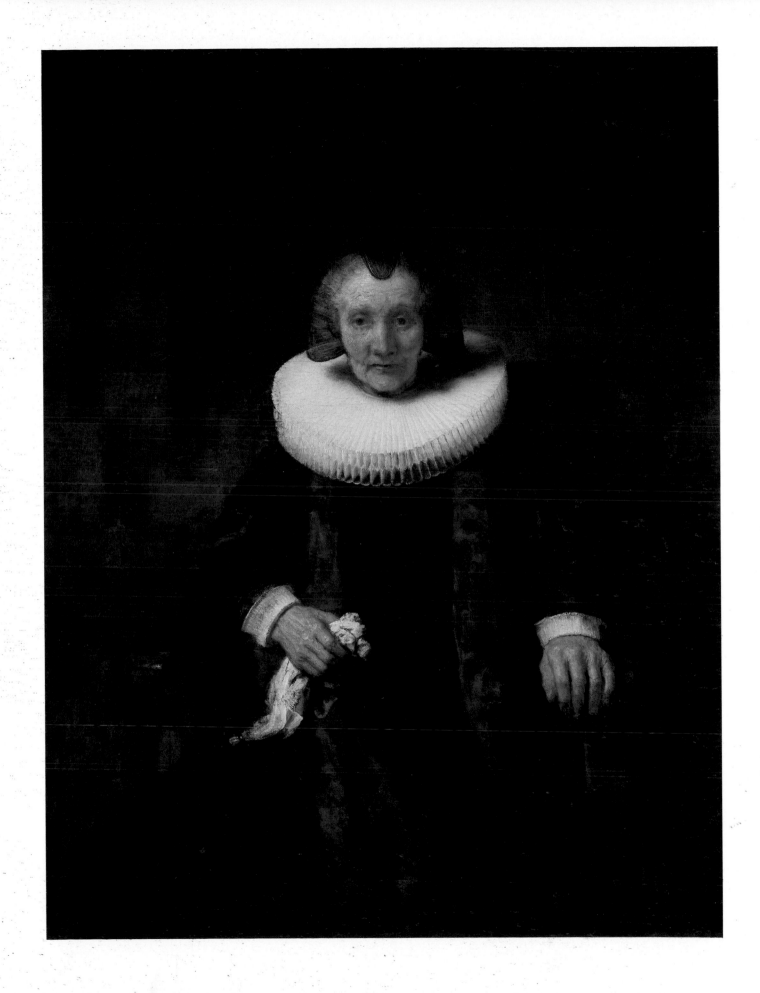

PLATE 37

Rembrandt van Rijn, 1606–1669

Portrait of the Painter at the Age of 63 (No. 221)

Canvas, 86 × 70.5 cms
Signed: Rembrandt f. 1669
Purchased, 1851.

This self-portrait, painted in the last year of Rembrandt's life, 1669, presents a remarkable contrast with the other self-portrait in the National Gallery, painted twenty-nine years earlier (plate 32). The youthful conqueror of Amsterdam has given way to a wild-haired, heavy-featured and simply-dressed old man, while Rembrandt's style has changed from careful modelling and tight descriptive brushwork to bold, heavy brushstrokes and the broad application of the palette knife. By 1669 Rembrandt had no interest in the detailing of clothing or of the physical setting of a portrait; in this self-portrait there is an absolute concentration on the face and, to a lesser extent, on the hands.

Rembrandt's self-portraits, of which sixty or so survive today, are unique in seventeenth-century painting and yet to treat them as a form of spiritual autobiography, as has been done, is misleading. The artist's face was remarkably expressive and he used himself as his own model in his restless search for new ways of representing the emotions. Comparisons, therefore, between self-portraits must be attempted with great care. If the mood of the 1640 Self-Portrait is self-confident while that of 1669 is resigned, that is to say no more than that the first depicts prosperous middle age and the latter wiser and sadder old age. But while many artists have observed the process of aging few have expressed it with greater poignancy than Rembrandt.

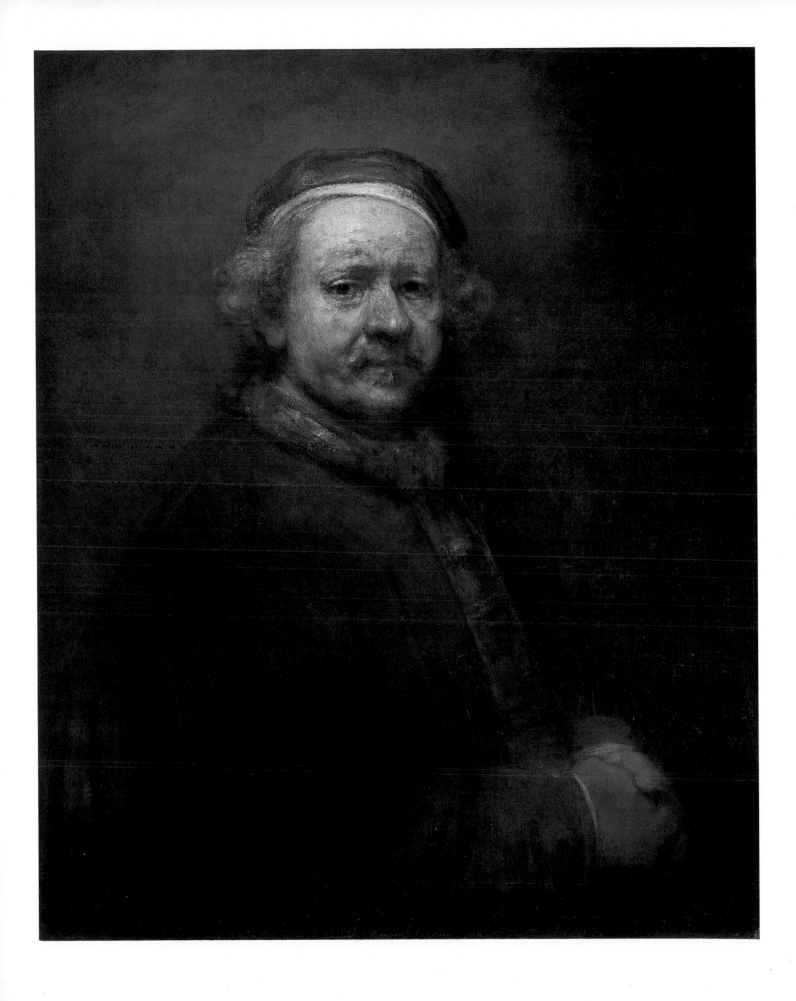

PLATE 38

Jacob van Ruisdael, c. 1628–1682

A Pool surrounded by Trees (No. 854)

Canvas, 107.5 × 143 cms
Signed, near the bottom and towards the left: JvRuisdael (JvR in monogram)
Purchased with the Peel collection, 1871.

Jacob van Ruisdael, the greatest of all Dutch landscape painters, was born in Haarlem. He was the son of a frame-maker and art dealer who is said to have painted landscapes, although none survive. Jacob presumably studied with his father and then with his uncle, Salomon van Ruysdael, one of the leading practitioners of the so-called 'monochromatic' style. Jacob joined the Haarlem guild as a master in 1648 and remained in the town until 1657, when he moved permanently to Amsterdam. Although he belongs to the Haarlem landscape tradition, Jacob was receptive to a variety of influences. He was, for example, a close friend of Nicolaes Berchem – they travelled along the German border together in 1650 – and looked carefully at his work and that of the other Italianate landscapists. As a direct consequence he varied and, in particular, lightened his palette. At the same time his compositions became increasingly monumental, the individual elements far more consciously arranged than in his uncle's work.

This painting dates from the second half of the 1660s, after Ruisdael's move to Amsterdam. The silver birches on the right call to mind the work of some of the Italianate landscapists (in particular Adam Pijnacker) while the mood of gradual yet inescapable decay strikes a melancholy note which is often present in the works of Ruisdael's maturity. It is tempting to think that in the decay and renewal of nature, Ruisdael, who was a member of an extreme Calvinist sect, the Mennonites, saw intimations of human mortality.

PLATE 39

Jacob van Ruisdael, c. 1628–1682

An Extensive Landscape with a Ruined Castle and a Village Church (No. 990)

Canvas, 109 × 146 cms
Signed, in the water, bottom right: J v Ruisdael (JvR in monogram)
Wynn Ellis Bequest, 1876.

In the late 1660s, perhaps inspired by the example of Philips Koninck, Jacob van Ruisdael painted a number of extensive landscapes, of which this is a particularly fine example. He uses a high viewpoint, devoting more than half of the canvas to a cloudy sky. Various attempts have been made to identify the church in the centre by its tower, but none has been convincing. This is presumably because Ruisdael did not intend this view to be topographically accurate: it is an imaginative landscape based on observed details. Ruisdael made drawings from nature and on his return to the studio combined elements from them in his painted landscapes.

PLATE 40

Salomon van Ruysdael, c. 1600–1670

A View of Deventer (No. 6338)

Oak, 51.8 × 76.5 cms
Signed and dated: SVR.1657 (VR in monogram)
Presented in memory of Rudolph Ernst Brandt, 1962.

Salomon van Ruysdael was the uncle of the better-known landscape painter, Jacob van Ruisdael. Salomon, who was born in Naarden, joined the painters' guild in Haarlem in 1623 and lived and worked in the town for the rest of his life. Salomon's master is not known, but his early style reveals his study of the Haarlem landscape painters Esaias van de Velde and Pieter Molijn. By the early 1630s he had discovered his own voice, in a series of delicate river landscapes, of which there is an outstanding example, dated 1632, in the National Gallery. At this time his technique is more precise than that of his contemporary, Jan van Goyen, although they both employed a deliberately restricted palette and are known as the principal practitioners of the so-called 'monochromatic' style. In the 1640s Salomon van Ruysdael's touch becomes broader and more assured; indeed his paintings of the 1640s and 1650s are among the greatest of all Dutch landscapes and are superbly represented in the National Gallery. In addition to this broadly-painted, light-filled panorama of Deventer, a small town in the province of Overijssel, there is in the collection a view of Rhenen – a town on the river Rhine in the east of the country – painted in 1648.

No drawings have been convincingly attributed to Salomon van Ruysdael and technical analysis has shown that in his early paintings, which are imaginary landscapes, he made underdrawings in charcoal on his panels. This view has no such underdrawing and was presumably painted in the studio with a topographical engraving of the town to hand. The profile of Deventer is accurate but it is its setting, outlined against a cloudy sky, with the river and the boats in the foreground, which make this such an effective composition.

PLATE 41

Pieter Saenredam, 1597–1665

The Interior of the Buurkerk at Utrecht (No. 1896)

Oak, 60.1 × 50.1 cms
Signed, beneath the drawing on the wall at the right, de buer kerck binnen
utrecht/aldus geschildert int iaer 1644/van/Pieter Saenredam (The Buurkerk at
Utrecht painted in the year 1644 by Pieter Saenredam).
Presented by Arthur Kay, 1902.

Pieter Saenredam, who lived and worked in Haarlem, specialized in church interiors and topographical views. He was one of the first Dutch architectural painters to represent buildings with absolute fidelity and he may well have been responsible for the emergence of a group of architectural painters in Delft in the 1650s. It was Saenredam's working practice to make a detailed drawing of his subject on the spot. From this he made a cartoon, sometimes years later, and the main elements of the composition were then transferred from the cartoon to the panel. In this case there is a drawing by Saenredam of the Buurkerk from the same viewpoint, dated 16 August 1636, in the municipal archives at Utrecht. This picture, painted eight years later, corresponds to the right half of the drawing, and a second painting, in a private collection, to the left half. The drawing is on a smaller scale than the painting and so must be Saenredam's on the spot study: the cartoon has not survived.

In his paintings Saenredam often modifies the accuracy of his drawings for compositional purposes, slightly adjusting the angle of vision, flattening arches, transferring monuments from one wall to another. In this case the artist followed the drawing closely but introduced the figures and dogs to break up the severity of the architecture. The background figures, which include – surprisingly – a group of turbaned Orientals, are by Saenredam himself, but it seems that he employed another artist to paint the boys in the foreground. The crude wall drawing, an invention of Saenredam's, shows the four sons of Aymon of Dordogne on their magic horse Bayard. Their story, which had been told for the first time in the thirteenth-century *chanson de geste*, *Renaud de Montauban*, was very popular in the Netherlands in the seventeenth century – new versions were published there in 1602 and 1619 – and the four brothers were to be seen on ceramics, textiles and even shop signs.

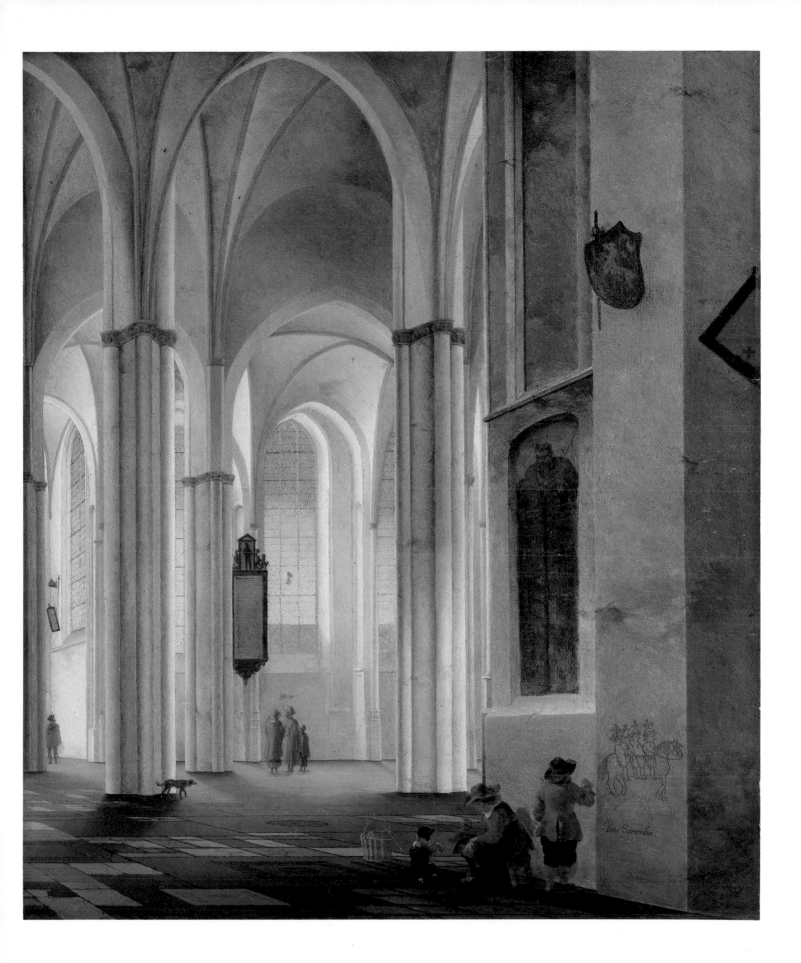

PLATE 42

Jan Steen, 1625/6–1679

Skittle Players outside an Inn (No. 2650)

Oak, 33.5 × 27 cms
Bequeathed by George Salting, 1910.

This idyllic landscape, with skittle players and figures seated on the grass outside the *White Swan* inn, is an unusual subject for Jan Steen, who is best known as a painter of rowdy domestic and tavern interiors. Steen, who was born in Leiden, was a remarkably prolific artist and his work has a wide range of subject matter in an age which encouraged specialization.

Steen seems to have been a pupil in The Hague of Jan van Goyen, whose daughter he married, and his earliest paintings are landscapes in a Van Goyenesque manner. Subsequently he was in Delft, one of the extraordinarily talented group of artists at work in the town in the 1650s. He later lived at Warmond (near Leiden), Haarlem, and in 1670 finally settled in his hometown. The apparent restlessness of Steen's temperament is reflected in the unevenness in his work; often in financial difficulties, he was not above hack work.

At his best, however, as in this painting which probably dates from around 1660, Steen can rise to a level of technical skill and lyrical mood rarely achieved by even the greatest of Dutch painters.

PLATE 43

Jan Steen, 1625/6–1679

The Effects of Intemperance (No. 6442)

Oak, 76 × 106.5 cms
Signed, bottom centre, J Steen (JS in monogram)
Purchased, 1977.

This large-scale figure painting is far more characteristic of the greater part of Jan Steen's work than the picture on the previous page. It is, however, of exceptional quality, as can be judged in areas such as the parrot and the dress of the kneeling girl.

The painting is an allegorical warning of the evils of alcohol, although, as is usual in the work of Steen, the mood is one of amused and indulgent disapproval, rather than Puritanical revulsion. The woman slumped on the left, whose pocket is being picked by a boy and above whose head is a basket of unused domestic utensils, illustrates the proverb 'Wine is a Mocker'; the boy on her left who throws roses before swine refers to a second (the equivalent of the English proverb – to throw pearls before swine); and the children who foolishly feed the cat, a third. In Steen's world children are often used to point up the foolishness of their elders.

The picture should be dated around 1662, shortly after Steen had enrolled in the painters' guild at Haarlem. It was bought by an English dealer in Amsterdam in 1829, and then passed into the collection of W B Beaumont, later Lord Allendale.

PLATE 44

Adriaen van de Velde, 1636–1672

Golfers on the Ice near Haarlem (No. 869)

Oak, 30.3 × 36.4 cms
Signed, at the bottom, towards the left: A V Velde. f/1668
Purchased with the Peel collection, 1871.

Adriaen van de Velde was one of a distinguished family of painters; his father and younger brother, Willem van de Velde the Elder and the Younger, were marine painters who in the year of Adriaen's death moved to London and soon after entered the service of King Charles II. Adriaen is best known today as a painter of landscapes in which figures and animals are often prominent. His earliest paintings reveal his study of Paulus Potter, and in the 1660s he painted a number of Italianate landscapes in the successful manner of Nicolaes Berchem. He seems also to have been much in demand to paint figures and animals in landscapes by other artists; he collaborated in this way with, among others, Jacob van Ruisdael and Philips Koninck. Adriaen's skill as a figure painter can also be seen in the few religious and mythological scenes he treated; the most remarkable is the large-scale *Annunciation* of 1667 in the Amstelkring Museum in Amsterdam. It was presumably because there were so few religious commissions of this type in the Calvinist Netherlands that he devoted his principal energies to readily saleable landscapes.

In this painting Adriaen shows a game of *Kolf*, an early form of golf, in progress on the frozen river near Haarlem. A makeshift tavern has been set up to cater for the thirsts of those citizens who have taken the opportunity to skate on the ice. It should be compared with Hendrick Avercamp's representation of the same subject (plate 1), painted half a century before.

PLATE 45

Esaias van de Velde, c. 1590–1630

A Winter Landscape (No. 6269)

Oak, 25.9 × 30.4 cms
Signed, below, centre, E.V.VELDE. 1623.
Purchased, 1957.

The town of Haarlem in the second decade of the seventeenth century was the crucible for the development of Dutch landscape painting. It was in 1612 that two influential landscapists, Hercules Segers and Esaias van de Velde, joined the local painters' guild. Both were trained in Amsterdam – Esaias was a native of that city – in the landscape tradition of Flanders, whose most outstanding exponent had been Pieter Bruegel the Elder. This type of landscape painting, which had become stylized in the work of Bruegel's followers, was bought to Amsterdam by refugees from the war in the south, the most notable of whom – among landscapists – was Gillis van Coninxloo. Esaias van de Velde, who may have been a pupil of Coninxloo, developed his style in the direction of greater realism. As can be seen in this painting of 1623, Esaias' mature style is marked by a striking naturalism created with free brushwork and a deliberately restricted palette. He had also studied the work of Adam Elsheimer, a German painter who worked in Rome in the first decade of the seventeenth century, in the form of prints and it is from Elsheimer that Esaias takes his low viewpoint and loosely triangular composition.

Not only did the art of Hercules Segers and Esaias van de Velde emerge in Haarlem at this moment, but also the delicate prints of Esaias' cousin Jan van de Velde, and the understated paintings and prints of Cornelis Vroom. Among Esaias' pupils was Jan van Goyen who was further to develop and refine his master's landscape style.

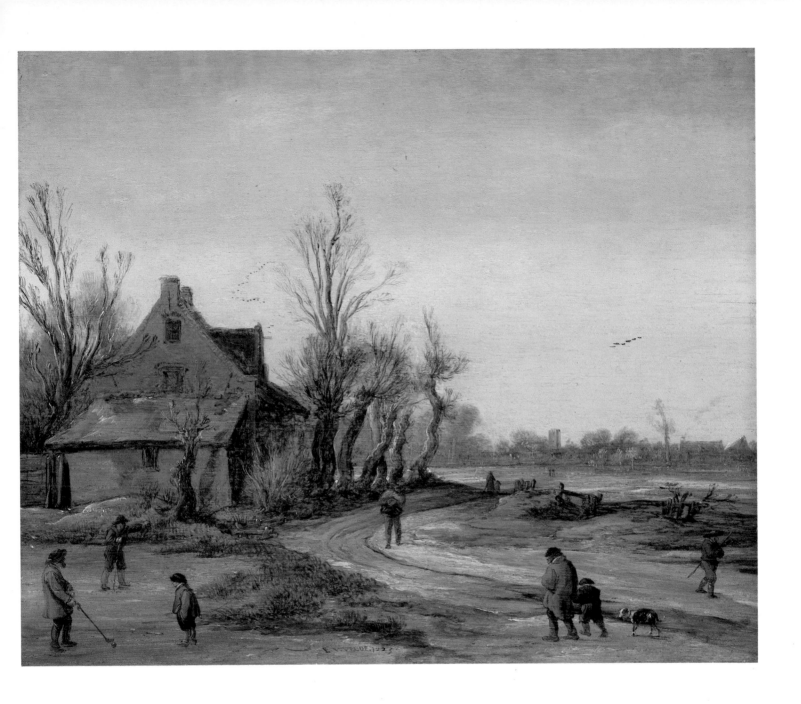

PLATE 46

Willem van de Velde the Younger, 1633–1707

Dutch Vessels close inshore at Low Tide (No. 871)

Canvas, 63.2 × 72.2 cms
Signed, on a beam, left foreground, W V Velde 1661
Purchased with the Peel collection, 1871.

Willem van de Velde the Younger was trained in the Amsterdam studio of his father, Willem the Elder, who was a skilled ship 'portraitist'. He worked in the city until 1672 when the economic dislocation caused by the French invasion made it difficult to earn a living as an artist. (Vermeer was also among the many Dutch painters who experienced financial hardship at this time.) Both father and son moved to England and in 1674 were taken into the service of Charles II. The royal warrant makes a distinction between their particular skills: the father was to be paid for the 'taking and making of Draughts of sea fights' and the son for 'putting the said Draughts into Colours'. They continued to live for the rest of their lives in England, working in their studio at the Queen's House, Greenwich, for Charles II, James II and members of their courts. Willem the Younger is buried in St James', Piccadilly, only a few hundred yards from the National Gallery.

This painting dates from 1661 when Willem the Younger was still working in Amsterdam. The scene, though based on the artist's drawings from the life, is imaginary, and he has included lively figures to lend animation to the groups of ships. The ones inshore are modest vessels, but further out are warships, one firing a salute and that on the left, broadside on, flying the flag and pennant of a commander-in-chief and the plain red ensign.

Johannes Vermeer, 1632–1675

A Young Woman standing at a Virginal (No. 1383)

Canvas, 51.7 × 45.2 cms
Signed, on the top left corner of the side of the virginal, I V Meer (the capitals in monogram)
Purchased, 1892.

A Young Woman seated at a Virginal (No. 2568)

Canvas, 51.5 × 45.5 cms
Signed, on the wall behind the woman's head, I V Meer (capitals in monogram)
Bequeathed by George Salting, 1910.

These paintings appear to be a pair. They have differing provenances in the eighteenth and early nineteenth centuries, but were brought together in the collection of the French critic Thoré-Bürger who is credited with the 'rediscovery' of Vermeer in a series of articles in the *Gazette des Beaux-Arts* in 1866. The paintings are of the same size, are complementary in their compositions, and both date from the final phase of Vermeer's career, around 1670.

Only about thirty paintings by Vermeer are known today and these appear to constitute most of his actual production. He must have worked slowly and meticulously, as the paintings themselves suggest, and he was not dependent on the sale of his paintings for his income: he inherited an inn and was also active as a picture dealer. He was born, lived and worked in the small provincial town of Delft. His master is unknown, although Leonart Bramer, a painter of small-scale religious and mythological scenes, who had spent a number of years in Italy, is the most likely candidate. Vermeer's earliest works are large figure paintings displaying his study of the Utrecht followers of Caravaggio and it was only in the 1660s that he came to appreciate the developments in genre painting brought about by Pieter de Hooch, Nicolaes Maes, Gerard ter Borch and others and turned to the depiction of the delicate, restrained domestic interiors by which he is best known today.

These two paintings have the almost porcelain-like smoothness of finish which characterize Vermeer's later work. The highlights, which shimmer and melt in earlier paintings, have become dabs of pure pigment. On the back wall of *A Young Woman standing at a Virginal* is a painting of a Cupid holding up a card which may well refer to the idea of faithfulness to one rather than the love of many. In contrast, the *Young Woman seated* has a painting showing a transaction in a brothel conducted by a procuress: the actual picture, by Dirk van Baburen, which Vermeer may have owned, is today in the Museum of Fine Arts, Boston. Vermeer was deliberately introducing, with this device of contrasted 'paintings within the paintings', the theme of love – in its numerous different forms – into these subtle, understated canvases. The theme is underlined in the second painting by the inclusion of the *viol da gamba* ready to be taken up by a lover who could then perform a duet with the young woman. (Compare, for example, the Metsu of a similar subject, plate 27.)

The first picture was purchased in the Thoré-Bürger sale of 1892 in Paris by a London dealer from whom it was bought in the same month by the National Gallery. The second, which was also in that sale, was in the collection of George Salting by 1900 and was bequeathed by him to the Gallery.

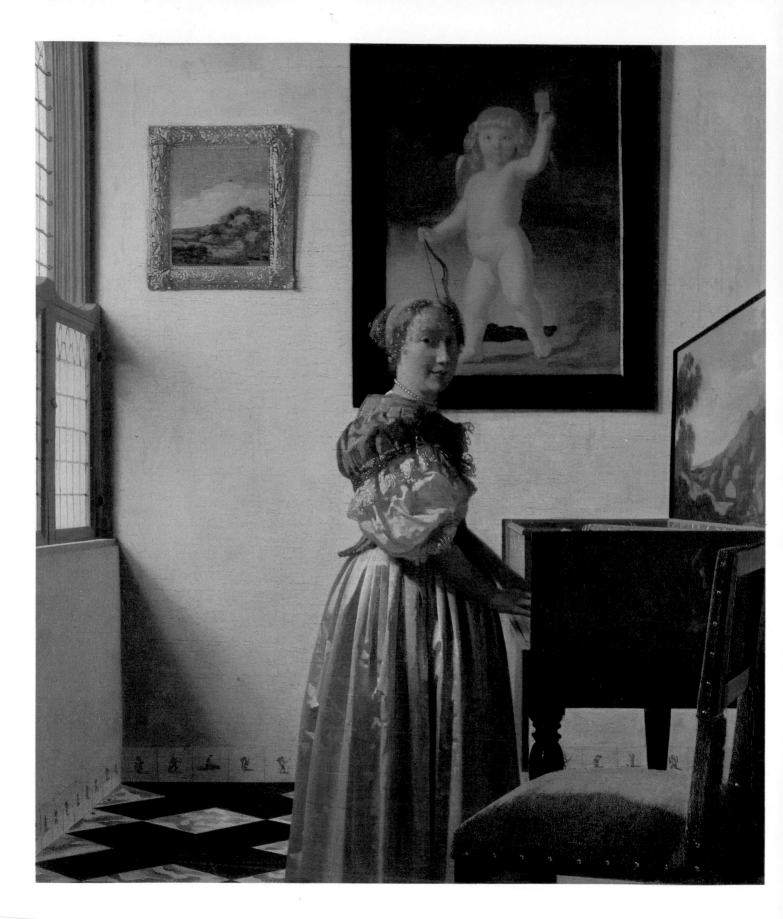

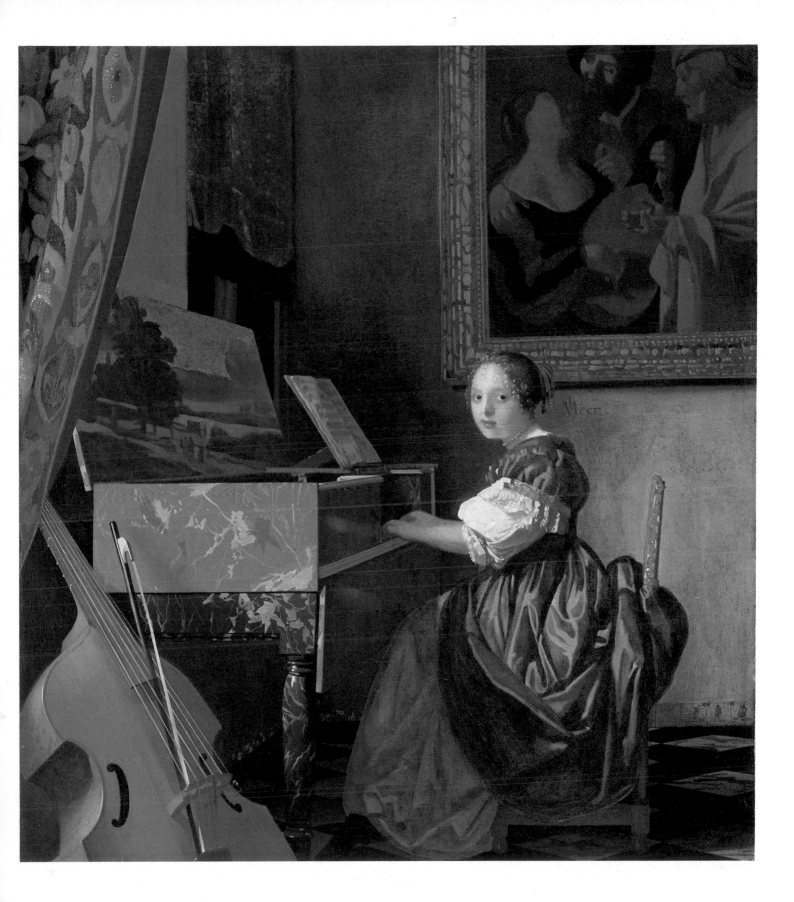

PLATE 49

Emanuel de Witte, c. 1617–c. 1692

The Interior of the Old Church, Amsterdam, during a Sermon (No. 1053)

Canvas, 79.1 × 63.1 cms
Signed, lower right, E de Witte
Presented by the Misses R. and J. Alexander, 1972.

The church interior is a distinct subject in Dutch seventeenth-century painting and its most important practitioners are Pieter Saenredam and Emanuel de Witte. De Witte, who was born in Alkmaar, settled in Delft in 1641 and spent ten years in the town before moving on to Amsterdam. It was in Delft in the late 1640s that De Witte began to concentrate on the painting of church interiors, an interest that he shared with two contemporaries in the town, Gerrit Houckgeest and Hendrick van Vliet. Houckgeest appears to have been the first painter who depicted church interiors in a realistic manner.

Bright daylight illuminates the whitewashed interiors, with their tiled floors, memorial tablets and heraldic banners. Figures are glimpsed between the columns and in front of the tombs, not all of them treating their surroundings with appropriate reverence. Among the worshippers, gravediggers and beggars are gossiping neighbours, unruly children and even urinating dogs. Houckgeest's new approach was taken up by Van Vliet and by De Witte, who was by far the greatest painter of the three. De Witte softened the harsh linearity of Houckgeest's style: unlike his Delft contemporaries, he was a sensitive colourist, offsetting the severe black and white of the church interiors with patches of bright reds, yellows and greens.

In this picture, painted after his move to Amsterdam, De Witte shows the interior of the Church of St Nicolas, the so-called Oude Kerk on the Dam Square. The view is of the nave and south aisle taken from a point in the north aisle and shows a sermon being preached from a pulpit erected in the nave. The uppermost glass in the right-hand window bears the arms of the city of Amsterdam; the glass in the central window shows the four Evangelists with their symbols. De Witte has made slight alterations, moving, for example, the small organ from the north to the south aisle.

The picture probably dates from about 1660. De Witte, who painted domestic interiors, harbour views, marine pictures and (after 1660) market scenes, as well as church interiors, seems to have had little success in his lifetime. Towards the end of his life he had considerable financial difficulties and at various times agreed to onerous contracts to paint in return for his upkeep. According to an early biographer, he committed suicide and was found in an Amsterdam canal which had been frozen over since his disappearance.

This painting was in the collection of the Edwardian collector and patron W C Alexander, whose daughters, Rachel and Jean Alexander, presented it to the National Gallery.

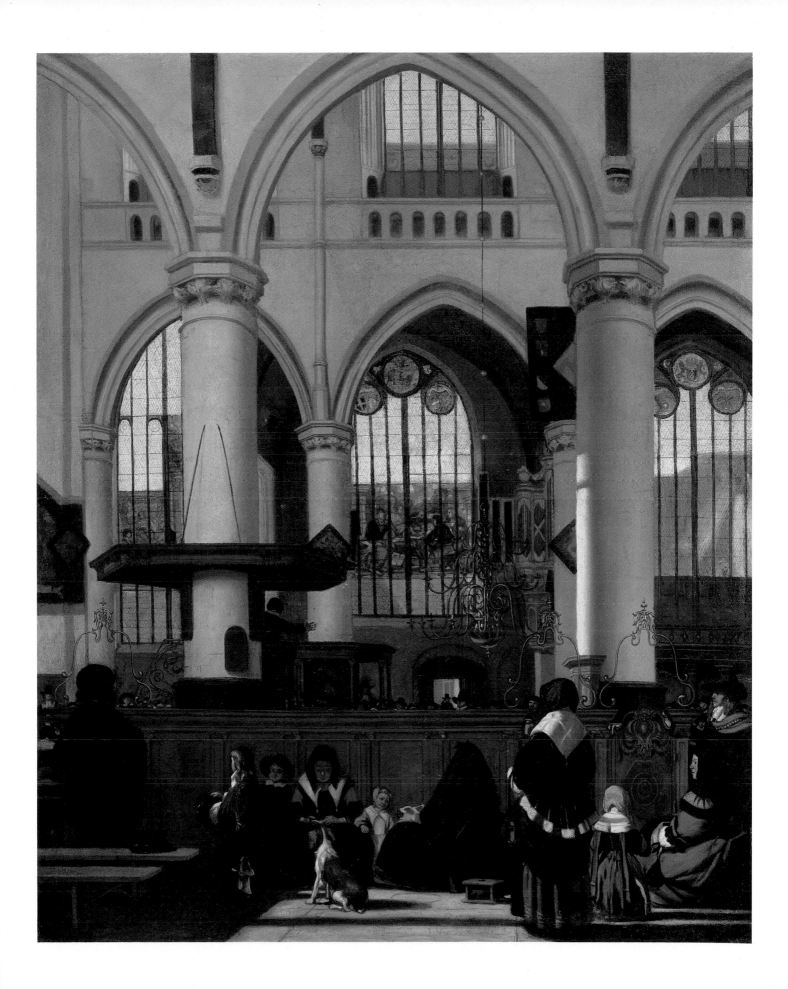

PLATE 50

Philips Wouwermans, 1619–1668

A View on a Seashore (No. 880)

Oak, 35.3 × 41.2 cms
Signed, bottom right, PHILS. W (PHILS. in monogram)
Purchased with the Peel collection, 1871.

Wouwermans was one of the most successful and, consequently, one of the wealthiest of Dutch seventeenth-century painters. The son of a painter, he was born in Haarlem, where he is said to have been a pupil of Frans Hals, but there is no real similarity in their styles, and Wouwermans did not paint portraits. He entered the guild in 1640 and lived and worked in Haarlem for the rest of his life. Wouwermans was an enormously prolific artist, specializing in scenes of riders in landscapes, often with battles, camps and hunts, but he also painted a few religious and mythological subjects. Among the National Gallery's ten paintings by Wouwermans is one of his largest battle scenes which is dated – very few of his paintings carry dates – 1646.

This is an outstanding example of Wouwermans' art. The subject of fishwives selling fish to a horseman on the dunes above a beach is entirely characteristic but the delicacy of handling and the subtlety of the palette make it exceptional. It was a recognition of its special qualities that caused earlier writers to describe it as Wouwermans' last painting. Although the chronology of the artist's work is difficult to establish in any detail, this is unlikely to be the case: his brushwork becomes finer and his palette lighter in his later years.

The painting has had a distinguished history, having been in the collection of Queen Isabella Farnese of Spain in the eighteenth century. It was brought from Spain by an English dealer and consigned for sale in London in 1813. Subsequently, it was in the collections of Lord Charles Townshend, who advised the Prince Regent on his purchases of works of art, and Sir Robert Peel.

Index to Plates

Note: page numbers throughout refer to the position of the illustrations